Banksy's Bristol

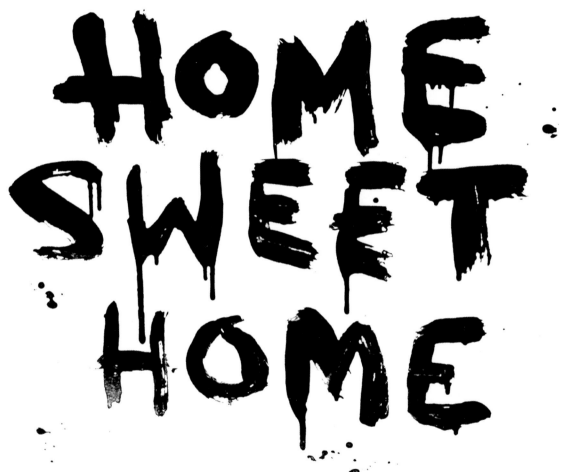

HOME SWEET HOME

The unofficial guide

by Steve Wright

Banksy's Bristol

HOME SWEET HOME

Edited by: Steve Wright

American edition published by Last Gasp
Ronald E. Turner, Publisher
777 Florida Street
San Francisco, CA 94110
www.lastgasp.com

Originally published in 2007 by Tangent Books
Richard Jones, Publisher
www.tangentbooks.co.uk

Design: Trevor Wyatt, Joe Burt.

Photography: Mark Simmons, Pete Maginnis, Trevor Wyatt, Matt Harrison, MKWF, Zombizi, Sarah Connolly, Ikue Uyama (relaxamax), Doppelganger, Charlie Black, Jack, Rebekah Kortokraks, Alice Lowndes, Tristan Manco, Anne Scott, D. Neary, R. Boyle, Ben Ekin.

Steve Wright thanks: Rach, my family, everyone at Tangent Books, everyone at Venue.
This book is dedicated to Banksy and the people of Bristol.

ISBN-13: 978-0-86719-708-2

09 10 11 12 9 8 7 6 5 4 3 2

Printed in China by Prolong Press.

Contents

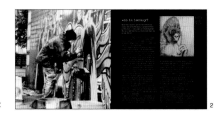

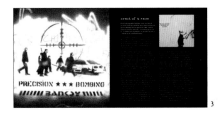

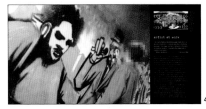

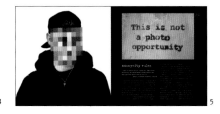

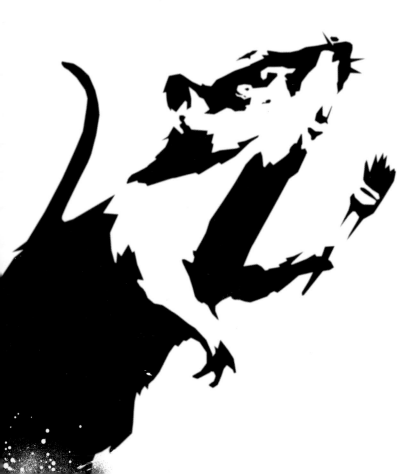

INTRODUCTION

So, why a book called 'Banksy's Bristol'? There's an awful lot of talk about the guy – he must be one of the most discussed, debated and acclaimed cultural figures of our age. A feat which is even more remarkable when you consider that his medium – visual art – is not usually one to grab the headlines.

And yet there is still very little known about where this all came from. Banksy's early graffiti career, and the amazingly fertile Bristol scene that nourished him, has not been given much attention. I wanted to understand a bit more about the Banksy phenomenon: how he has achieved what he has, where and when it originated and, finally, what it means – for the art world, for Bristol, for people that knew him then and know him now. I wanted, in short, to get to the bottom of his art, to understand where it came from and why it has taken him so far.

This book is an appreciation of Banksy's art, and explains why it has had such an immense impact; it looks at the targets Banksy chooses and how he nails them so effectively, with a mix of sharp humour and humanity; and it traces his roots back to Bristol's astonishingly rich graffiti and music landscape, looking at and hearing from some of the key protagonists in the scene that came out of a small city and made an impact upon the wider world.

Banksy enjoys an extraordinary, unique sort of fame. 30,000 people saw *Barely Legal*, his Los Angeles exhibition in September 2006. And people just love talking about

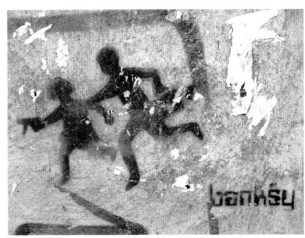

One of Banksy's first Bristol stencils. The tag soon changed into the one that is now recognised across the globe.

the guy. There are hundreds of photo-sharing websites devoted to pictures of his art, and hundreds more chat rooms discussing his style and alerting fans where the latest piece has gone up. During the course of my research, I trawled through old copies of the *Bristol Evening Post* and found that, between 2005 and 2007, a Banksy story would come up roughly every fortnight. So much intrigue surrounds the man: about his identity, for sure (for we all love a mystery), but also around his art, and a sharp strain of humour within it that speaks to people quickly and crisply.

"He's had the impact he has for many reasons," notes one (anonymous) friend and collaborator. "Being in the right place at the right time certainly comes into it, as does his sheer drive and work ethic. Chiefly, though, his style was simple enough for your average Joe to get. When he first started to become known outside his circle of artists and friends, it was people like builders and office workers that seemed to be picking up on his humour."

But some of the most striking parts of the Banksy story are the gaps, the bits that aren't known – who he is, what he looks like, where he hangs out and with whom. In a celebrity-obsessed era, Banksy has created a universally-recognised brand without revealing his own identity – an extraordinary feat.

For many artists – particularly graffiti artists – art is ego-driven, all about getting your soul, your emotions or simply your name onto a wall or canvas. Not so for Banksy. What do we learn about him, as a person, from his pieces? Very little – which helps to feed the fires of intrigue. It's not just Banksy himself who's anonymous: his art somehow is, too.

Another part of the fascination with Banksy is that we don't yet know how he will be remembered, how much impact he will be judged to have had. It could be that he has changed the art scene massively by turning a whole new generation onto art. But where will the Banksy story take us next? Will he ever reveal himself? Will he eventually mellow, when he gets older and shinnying up a road bridge at 3am doesn't seem quite so appealing? Will he retire with a few goats to Cornwall? Of course, given his mystery, most of us will probably never know, although revealing himself and living off the interviews would be another option open to him. Probably not, you suspect, one he'll choose.

Finally, it was never our intention to reveal Banksy's true identity (though we could have published photographs of him) and I was impressed that it was only when I made this absolutely clear to the interviewees that they were prepared to talk about Banksy and his Bristol background. That loyalty seems to have been engendered by the fact that Banksy has never sold out. And because Bristol is very proud of him.

Steve Wright, Bristol, 2007

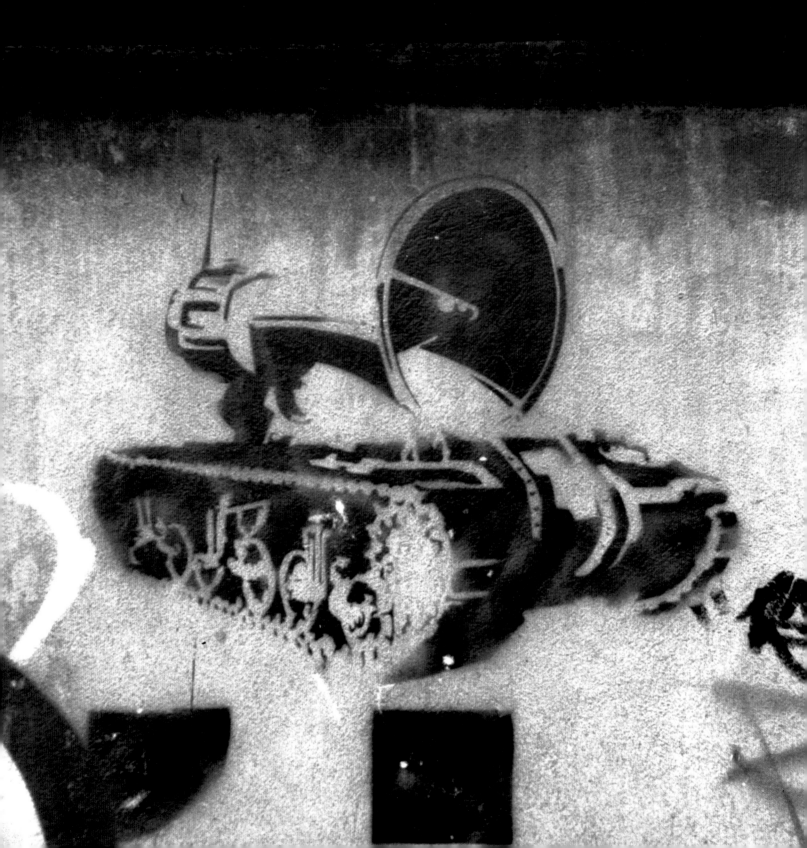

the bristol beat

"I come from a relatively small city in southern England. When I was about 10 years old, a kid called 3D was painting the streets hard. I think he'd been to New York and was the first to bring spray painting back to Bristol. I grew up seeing spray paint on the streets way before I ever saw it in a magazine or on a computer.

"3D quit painting and formed the band Massive Attack, which may have been good for him but was a big loss for the city. Graffiti was the thing we all loved at school – we all did it on the bus on the way home from school. Everyone was doing it."

Banksy, interview with *Swindle* magazine

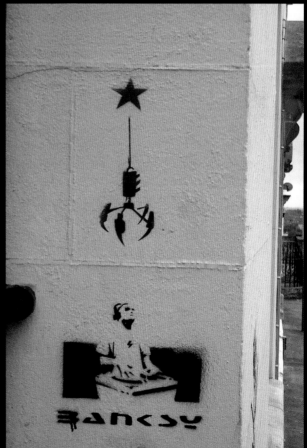

Any account of Banksy's impact has to take in the larger context of street art in Bristol. For it's no coincidence that Banksy grew up, and made his first pieces, in a city with a rich graffiti and street art tradition from the early 1980s onward. In the early days of Bristol graffiti culture, four figures emerge as key. There right from the very start, as Banksy mentions above was Robert del Naja, aka 3D, who started out as a young graffiti artist spraying on Bristol walls in the very early 80s. More than that, 3D was responsible for importing some of the American hip hop and graffiti culture over to Bristol, bringing leading artists connected to the seminal NY hip hop/graff outfit Rock Steady Crew to paint over here. He went on, of course, to

That page:
The tank used to be on the same wall in Frogmore Street as the 'window hanger' is now.

This page:
The freehand piece was off St Mark's Road in Easton and the DJ was in Clifton.

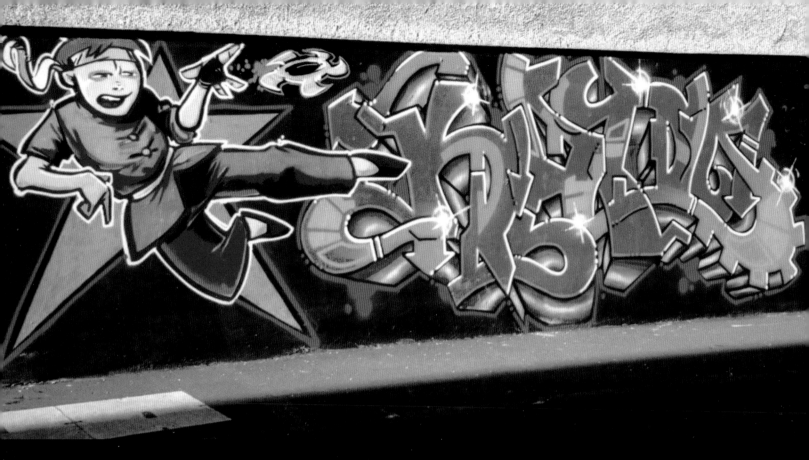

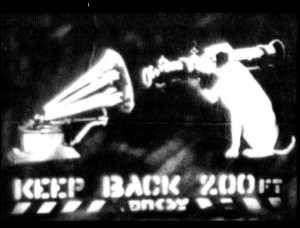

form the hugely successful Bristol band Massive Attack, perhaps an even more prominent and distinctive part of Bristol's cultural profile than Banksy himself.

Second in the hall of fame is John Nation, who in the late 1980s was youth leader at the Barton Hill Youth Centre, in a densely populated area just east of central Bristol. Nation gave young artists wall space at the Centre and allowed them to express themselves – much of Bristol's best graffiti from the time was produced by young graffers cutting their teeth at BHYC. In fact, at this time, walls around town were being painted to such a high standard that a set of postcards by photographer Frank Drake was published by Arnolfini celebrating some of the city's best graffiti.

The third figure is linked to the last two. Inkie, a protégé of 3D's who also formed part of that Barton Hill group, is one of the most important figures on the Bristol scene and in the Banksy story. Inspired, like 3D, by 1982's seminal old-school graffiti/hip hop film *Wild Style*

Inkie began painting freehand graffiti in around 1984, collaborating with 3D and our fourth key figure, Nick Walker, as part of the seminal 80s graffiti crew Crime Inc. These three (Walker, Inkie and 3D) all became a huge influence on future generations of Bristol graffers. Inkie came second in the World Street Art championships in 1989 and in the late Nineties, he and Banksy collaborated on pieces around Bristol, most notably 1998's *Walls on Fire*, a graffiti festival in the centre of town.

Back in 1982, Walker became the first Bristol artist to adopt the stencil form – and thus has been a big influence on Banksy's later career. He's now a high-profile artist and designer, working with hip outfitters Kangol and providing graffiti backdrops for films like *Eyes Wide Shut*, *Judge Dredd* and *Hackers*. Like 3D, he still lives in Bristol. His stencils, often with a cheeky and provocative flavour similar to Banksy's, continue to sell across the globe.

Stephen Morris is a Bristol photographer who has documented some of the city's rich graffiti culture in a book, *Off The Wall* (Redcliffe Press). In his view, Bristol is the graffiti capital of Europe. "It is a striking feature of Bristol life," says Morris. "The city is the European leader in this form of art. Graffiti is by nature temporary. Taking the pictures for my book, I found I couldn't walk fast enough to keep up with the changes. Even the best is soon lost under fresh paint or to a demolition gang and some wears out and is replaced."

The city's art scene, too, has always been lively, with a huge amount of artspaces from conventional galleries to more temporary spaces. In 2002, a Bristol City Council report on the City's Capital of Culture bid noted that 'Bristol has more working artists than any other city outside London.' Various theories have been put forward on just why Bristol has always fostered such a strong street art tradition. Inkie has noted, succinctly, that Bristol is: "A beautiful Georgian city with a very creative outlook and attitude tucked away from the rest of the UK… It also has a lot of good cider, weed and mushrooms."

Stencil artist Ghostboy, who's still doing his stuff around the city, puts the energy here down to various outside influences. "There's something about the place – an underground, anarchic quality, which is quite apparent in places like Easton [an inner-city area with a diverse racial makeup and a strongly alternative feel, where Banksy lived and painted prolifically]. There are a lot of activists here, and it's quite a liberal place. I think that influences the way that artists work – they don't toe the line as much. And it's not just the art, there's a general vibe about Bristol, which is all about doing what you want to do, not being beholden to others."

It's true that Bristol has a proud tradition of resistance – from the Queen Square riots of 1831, via some prominent suffragette activity, to the 1980 St Paul's riots and, more recently, *The Bristolian* scandal sheet, the Bristol Blogger and the strong subvertising culture.

Ghostboy adds: "We've also had an influx of different cultures coming to Bristol, what with it being a historic port – for example, there's also a very strong performance poetry scene here which, like the street art, is a very American influence. We have a very varied mix of cultures, and that can only be enriching."

Fellow graffer Cheba says: "It was a lot to do with 3D going to and from New York, bringing back lots of graffiti writers. Bristol is such a small community, it's not hard to get your name around, everyone knows everyone on the scene. In London, there are graff communities, but they're much more scattered, less close-knit."

Banksy collector Gez Smith has another take on it all. "I remember seeing a programme on BBC4 about the 1950s, and how floods of cannabis came into Britain at the time, through two ports: Bristol and Liverpool. From Liverpool, it may have spread out across the north-west, but it seems as though it all just stopped in Bristol. Add to that the fact that the West Country has always been a somnolent place, everyone's very laid back and chilled out – that's why we've got movements like Slow Food and trip hop being born here. All that stuff contributes to Bristol's creativity, people are more laid back, not so bothered about getting to work on time. And there's always been a strong left-wing thread in the city."

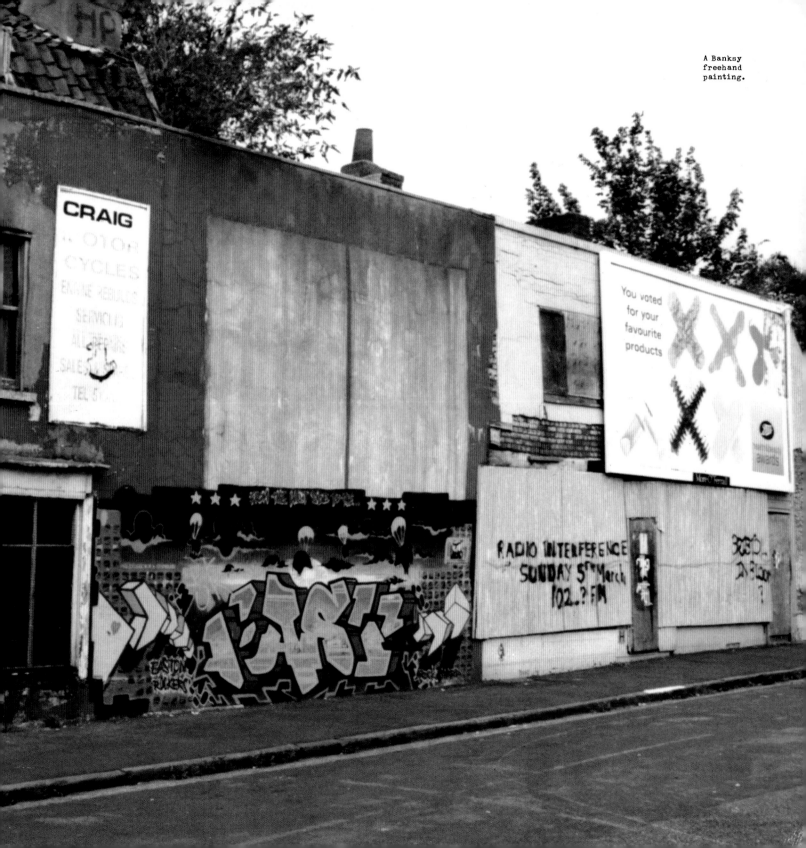

A Banksy
freehand
painting.

3D from Massive
Attack at the
Graffiti Art
in Bristol
exhibition at
Arnolfini in
1985.

On a more practical level, there's the wealth of canvasses out there for street artists to use. According to the editors of *Bristle* magazine, who produced a book of Bristol political street art and subvertising: "Bristol has loads of empty buildings that are allowed to rot despite widespread homelessness and poverty; huge parts of the city are blighted by planning for cars, not people, and by provocative advertising hoardings. It's often about local people making their own mark on a dreary alienated urban environment."

One seminal moment early in the Bristol graffiti story was in July 1985, when the city's Arnolfini art gallery held an exhibition, *Graffiti Art in Bristol*, documenting the fledgling art form. Artists including 3D, Nick Walker, Z Boys, Bombsquad, Fade and Jaffa sprayed directly onto the gallery walls, and there was music from a young hip hop crew called The Wild Bunch, later to evolve into Massive Attack. Other future Bristol music luminaries – Tricky, Smith and Mighty – were in the audience. A teenage hip hop kid called Geoff Barrow also travelled in from his home town, a place called Portishead.

With the likes of Walker, 3D and Inkie spearheading the scene and other artists such as FLX and Paris emerging, the late 80s were an incredibly fertile time. In 1989, though, the scene was hit hard by Operation Anderson, a massive undercover police crackdown on graffiti. A total of 72 artists across the UK (Inkie among them) were arrested on criminal damage charges. John Nation was also charged (though later acquitted) with incitement to commit criminal damage. The effect was to send graffiti

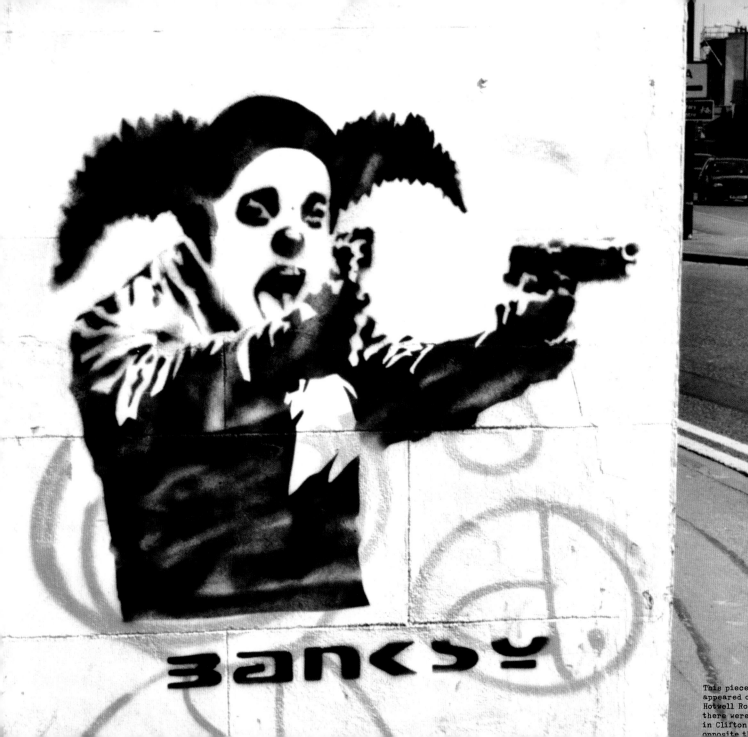

BANCSY

back underground for several years. Recently, though, the Bristol graffiti scene has regained all of its original verve and inventiveness. It's also more populous than ever. Ghostboy, Kato, Mr Jago, Tristan Manco, Dicy, Xenz, FLX, Paris and Sickboy are all prominent names in Bristol and far beyond: some are still doing their stuff here, others have beaten a path to London. Each of them, though, is a leading light on the global graffiti scene, and each of them honed their art right here in Bristol. For a city of its size, Bristol has made an awesome contribution to the art form.

Special K's and The Wild Bunch

"I remember meeting Inkie while he was doing a piece in Clifton in broad daylight… must have been 1985 or 1986," recalls Chris of music project Illusive. "I also remember Inkie and Crime Inc. Crew spraying up our school in around 1987 or 1988, they did the whole wall of our school gym. I even remember some of the teachers saying 'What an amazing piece of art!'

Nick Walker recalls: "We used to get together at a café called Special K's, at the bottom of St Michael's Hill. It was pretty much home to The Wild Bunch at the time, and it attracted a lot of like-minded people. Just a pool table and graffiti on the walls by 3D. And there were a lot of sound system parties. Bristol in the 80s, that was when the proper parties were. No flyers or anything: you'd turn up at a house, there'd be no furniture and it would just be rammed, wall to wall."

Nick Walker on art and music in mid-80s Bristol

"I was 15, I just walked in off the street and suggested this graffiti exhibition to them. Jeremy Rees [Arnolfini founder] welcomed it with open arms. I spoke to 3D and the rest of The Wild Bunch, and some other graffiti crews who were around at the time. 3D took over the running of the show, and it was a great event. I don't think that would happen these days in any large art establishment. There was graffiti all over the walls; people were coming over from New York and elsewhere. It felt like the beginning of something special."

A Banksy piece at Ashton Court Festival, created in exchange for cider.

This page:
The walls of
Easton were
the canvasses
for much of
Banksy's early
freehand work.

That page: The
girl with a bomb
appeared on the
Harbourside but
only lasted a
few days.

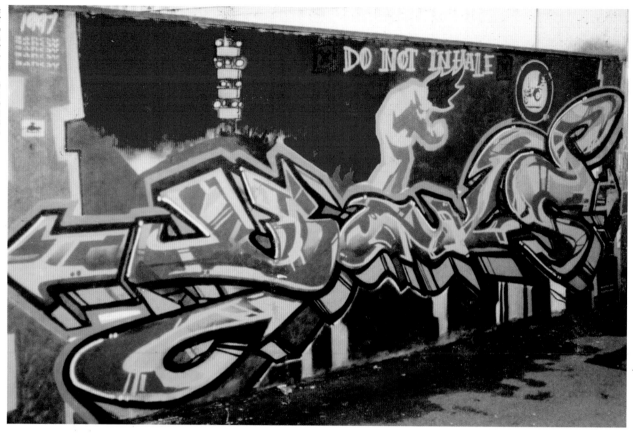

Banksy and hip hop culture

Azlan was one of many people heavily involved in the late 90s music and graffiti scene in Bristol. He was a member of both Bristol hip hop group Aspects and Fantastic Super Heroes, a hip hop/graffiti crew which also included Paris, Dicy, Feek and Mantis.

"The Bristol art and graffiti scene has never been documented properly," he says. "Banksy was one small (yet successful) part of that scene."Instrumental to Banksy's development and the continued flourishing of the Bristol scene throughout the 1990s were a slew of writers infamous for changing their names more often than they changed their socks. Alongside artists Shim and Turoe was one crew comprising the artists Kato, Lokea, Juster, Soker and Tes. Originally known as MBA, they then became Bad

Apples and finally DBS which, according to one source, stood for DryBreadS – a reference to being so fiscally challenged they couldn't afford any spread for their toast.

3D was never really a part of what happened in the mid to late 90s," says Azlan, "although he may have been an inspirational figure through his early- Bristol graffiti days and artwork for Massive. Nick Walker, however, has always been there, and worked alongside other Bristol artists such as Paris, Eko, Dicy, Feek, Xenz, Will Barras, Mr Jago and, of course, Banksy.

The Bristol hip hop scene
"The main thing that brought everyone together in Bristol was the hip hop scene of the mid to late 90s. Forget Massive, Portishead and Tricky, I'm talking about the underground scene – Bristol's Hombre Records, special hip hop events and club nights run by the FSH (Fantastic Super

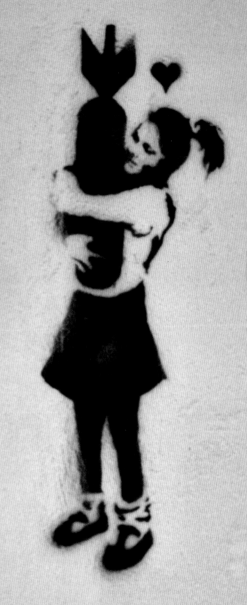

BANKSY

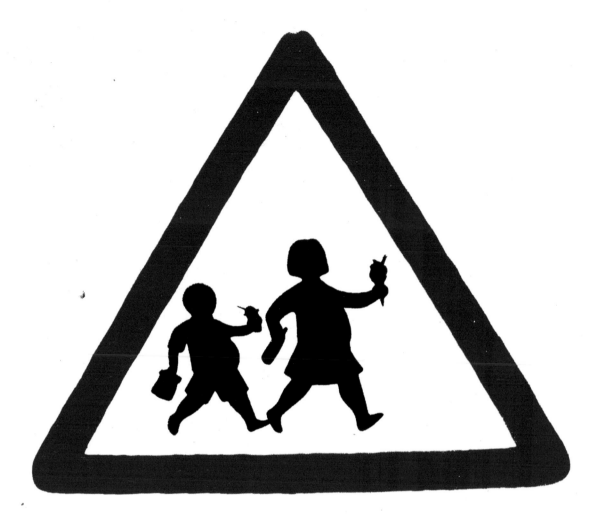

SLOW
CHILDREN

BNK/5Y 021

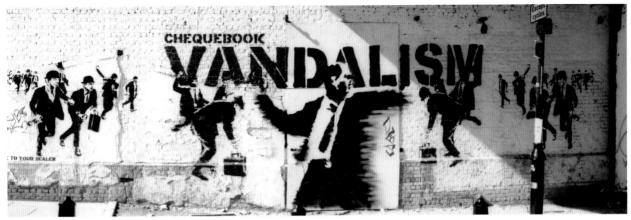

Heroes) and Bristol bands Aspects, Parlour Talk, Numskullz and Onecut to name but a few.

"These were all groups of people brought together by the love of hip hop – not rap music or some chav gangster modern R&B tinged tosh – I mean underground, leftfield, creative, pioneering hip hop.

"Hip hop, is essentially about its 'Four Degrees': MCing, turntablism, breakdancing and, of course, graffiti, and that's exactly what we all did. Kept behind closed doors for years, bedroom DJs and covert graffiti artists now had a public forum. Local press and major record labels didn't really want to know, but UK hip hop and its strong visual identity was steadily crowbarred back into the media's gaze, locally and then nationally –most notably in magazines like *The Face* and *Sleazenation*.

Fantastic Super Heroes

"Hip hop is about one-upmanship," continues Azlan. "So, with all the talented artists and musicians who just happened to collide around the late 90s, Bristol became a creative hot spot with artists bouncing ideas off each other and striving to create the biggest and best 'piece'. Often artists worked together to paint walls in 'halls of fame' such as Bedminster skate park or under the M32 at Eastville.

"The Fantastic Super Heroes were a crew of people brought together by hip hop. Original members were myself (Azlan), El Eye, Mantis, Bubba, Nick Fury (all Aspects), Paris (TCF), Dicy (Kuldesac), Sir Beans OBE (Parlour Talk) and rapper/DJ Awkward. The idea for the crew was to be

something like a Bristol version of The Rock Steady Crew and all those original 80s hip hop crews from New York. We combined all the elements: emcees, turntablists, graffiti artists. We even had a stab at breakdancing…

"From that core of people, the crew expanded so rapidly that identifying who really was an FSH member is virtually impossible. I think that, come the *Walls on Fire* graffiti event at the harbourside in 1998, we talked about having 60-odd members. The FSH was probably only active for about a year, as various people soon splintered off to do their own thing. Most of the graff artists became the TCF crew (Twentieth Century Frescoes). Bands emerged, too, like Aspects, Onecut, Numskullz, Parlour Talk.

The Bristol scene goes global

"As a graphic designer and original member of the FSH and Aspects, I worked with most of the street artists and illustrators, giving many their first break in print, from simple club flyers, to music magazine features and record sleeves. Most artists were either unemployed or in dead-end call centre jobs, but slowly, as things took off, they began to make their art pay the bills.

"The media and advertising companies began to take notice as the visual language of hip hop became something everyone wanted to be associated with. The result was that various artists were cherry-picked to work on bigger, higher-profile projects. Some artists from the scene have since been invited to paint and exhibit their work all over the world from Bristol, to LA to Japan."

Inkie on Banksy

Inkie has always been one of the best-known and most inventive artists on the UK street art scene, blending a huge variety of styles – he cites Inca art, Egyptology, William Morris, Art Nouveau and even children's illustrator Richard Scarry among his influences.

He started painting around Bristol in 1983 alongside Massive Attack's 3D, Nick Walker and Goldie, the future drum 'n' bass legend who started out as a graffiti artist in his native West Midlands. In 1989, Inkie and fellow Bristol graffer Cheo came second in the World Street Art championships, beating off competition from Los Angeles, New York and various European countries.

Later that year, Inkie hit the national headlines when he was arrested as 'the Kingpin' in Operation Anderson, the UK's biggest-ever graffiti bust. British Transport Police and Avon and Somerset Constabulary raided the homes of 72 suspected graffiti writers in and around Bristol and Inkie was accused of causing £250,000 worth of damage to Clifton Down Railway station. His arrest, court case and subsequent acquittal were recounted in a BBC2 documentary *Drawing The Line*.

Almost a decade later in 1998 he and Banksy organised the UK's largest graffiti event to date in Bristol. *Walls On Fire* pulled together the UK's finest street artists to create a 400-metre painting on hoardings around the Harbourside.

Inkie is now a leading designer for the video-game industry, and continues to contribute to the UK street art scene. A show of his work and that of other Bristol artists is scheduled for 2009 at the Royal West of England Academy.

Why do you think Banksy has had the impact he has?
Because of the PR and press backing for his work done by the team he has built up around him. He attacked the scene with a military precision, choosing key events and locations and transport hubs to bomb with his work and releasing images to press afterwards. No-one had done this as well before him.

How would you class his style?
Iconic. Political. Ballsy.

London artist Mode2 worked with Inkie and Banksy on Take The Money and Run opposite the Old England pub in Montpelier.

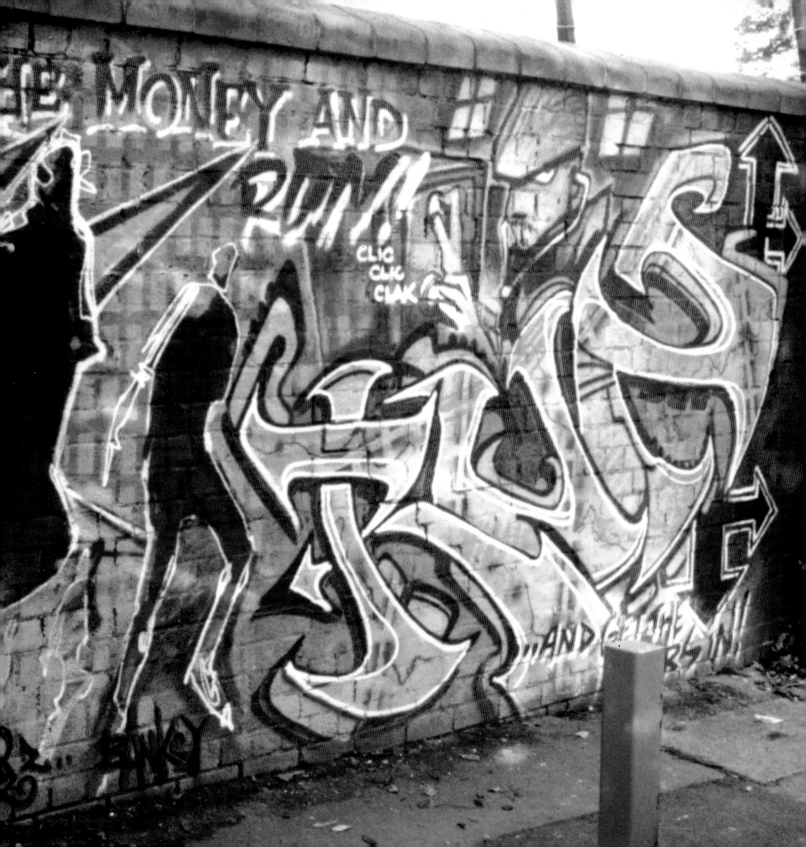

SADIA
LIVE

BY ORDER
NATIONAL HIGHWAYS AGENCY
THIS WALL IS A DESIGNATED
GRAFFITI AREA
PLEASE TAKE YOUR LITTER HOME
EC REF. URBA 23/366

What are your memories of painting in 1983 alongside 3D and Nick Walker as part of Crime Inc.?

Myself, 3D and Nick were definitely there at the forefront of the Bristol graffiti scene, but there were many others: Jinx, FLX, Fade, Jaffa, Toots, Tarzan, the Z-Boys and the Barton Hill crew. We were all driving each other forward on the buzz of doing illegal work in the mid Eighties to early Nineties.

Does Banksy follow on directly from the likes of you, 3D and Nick Walker? Or has he developed in a different direction?

3D and Jody, an artist from the Barton Hill Youth Centre, were doing stencil work in the late Eighties. But for most graffiti writers back then, using a stencil was seen as taboo. We all worked freehand.

I was well aware of the Parisian stencil scene, but in Bristol, we were all about large-scale 'bombing'. Banksy used stencils to his advantage to get up a lot more stuff, and faster, with less risk of being caught. Nick's work has evolved and he is using more stencils now than before.

Memories of Operation Anderson?

I'd been nicked quite a few times before, but on that occasion I was up in Liverpool and got a phone call from my brother saying that my parents' house had been raided and that they'd arrested 70 other people. It was all over the local news and was covered in the national news. I went back down to Bristol to turn myself in and found out that they'd nicked nearly everyone that I'd painted with. The police had found someone's diary and gone through it, matching the numbers to the writers.

***Walls on Fire* seemed like a renaissance for the Bristol scene…**

It brought a lot of writers together who hadn't spoken or had contact in a long time and helped to create a resurgence of the UK scene. I helped Banksy organise the event but took a bit of a back seat and got pretty drunk on the day if I remember rightly.

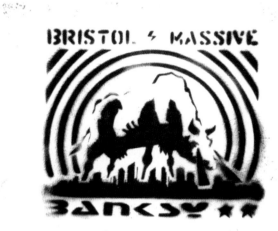

Why did such a strong scene grow up in Bristol?

Geographically, Bristol was cut off, so we developed our own styles. Also there was no internet back then, so it was all about exchanging photos. You had London up the M4 where people used to go every couple of months and take photos of graffiti and buy trainers, and you also have a big Jamaican community in Bristol, so people would bring music over from New York and Jamaica.

There aren't really any other major cities around, it was its own city and that's why it developed its own scene. But we still managed to create a worldwide network of writers and had several trips around Europe and the States.

Did the music and graffiti go together?

About six months after I started doing graffiti, I gradually got into hip hop. The Wild Bunch were doing a lot of parties. Everyone wanted to put on the best hip hop shows. It was like this small corner of south-west England consumed by New York.

Is Banksy well-respected among the graffiti crowd because he avoids commercial work?

He sticks to his guns, and that is something to be admired in anyone. He's no sell-out.

Cheba on Banksy

Cheba is a Bristol-based graffiti artist who has been painting around the city for some seven years. Unlike Banksy's later work, he favours a freehand graffiti style rather than stencils.

When did you first get the graffiti bug?
I first got into graffiti when I started seeing pieces by Inkie around town. I'd always been a keen drawer from childhood. I'd never considered myself as a graffiti writer because I wouldn't do the traditional tags and letterforms, but I seemed to be thrown into that category. I got into stencils around 2000 but I lost the love of stencils pretty quickly.

Why? Because he was dominating the scene?
Basically, yes. But I also realised it wasn't the route I wanted to go down. I moved on to posters then I got more into freehand stuff. I guess I was experimenting with what I could do and what I could get away with.

How do the two forms compare?
Stencil graffiti is hard to get right. Many view it as a bit of a cheat, though, because it can all be done beforehand, whereas with traditional graffiti you've got to spend a lot more time actually up there doing the piece. With the stencils, you can do all your preparation at home – which is a lot more painstaking, but the risk levels are less. Stencil, though, is a lot harder to make look like your own, to achieve an individual style.

Was Banksy an inspiration?
He inspired me to start doing it in a way (as well as just being in a city such as Bristol) not through his art, but by being so prolific. He'd 'bomb' a part of town and you'd suddenly be seeing his work everywhere. For me, he's more about the message than the art – I don't think he cares too much about what the art really looks like, I think he's more about taking the piss. It's more about getting across a visual joke than the quality of the art.

Top:
An example of one of Cheba's characters.

Mild Mild West

Bristol writer and publisher Richard Jones on Banksy's 'Welcome to Bristol' sign...
"Some of Banksy's fellow artists from outside Bristol are said to be dismissive of his iconic Mild Mild West mural. Apparently, the font Banksy uses for the Mild Mild West wording has been singled out for particular criticism.

"Yet for many Bristolians, this is Banksy's signature piece – it's like an alternative 'Welcome to Bristol' sign, and its impact has as much to do with its position as its content. It's impossible for anyone who has lived in Bristol for a long time not to see Mild Mild West as a reference to the St Paul's riots of 1980 which started with a police raid on the Black and White cafe on nearby Grosvenor Road. I've always thought it's like a Blue Plaque for the rioters.

"The riots had an immense cultural resonance in Bristol as they came at the height of the reggae movement coming out of St Paul's with bands such as Black Roots and Talisman; Barton Hill scaffolder Gary Clail was teaming up with Adrian Sherwood at On-U-Sounds to produce a fearsome bass-heavy form of dub with warped up

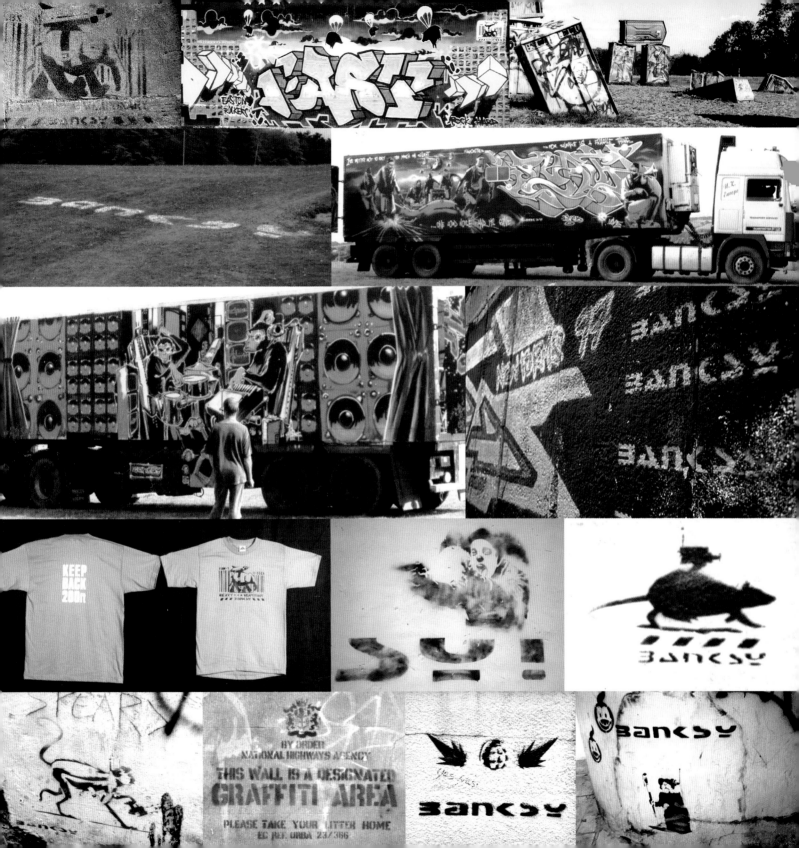

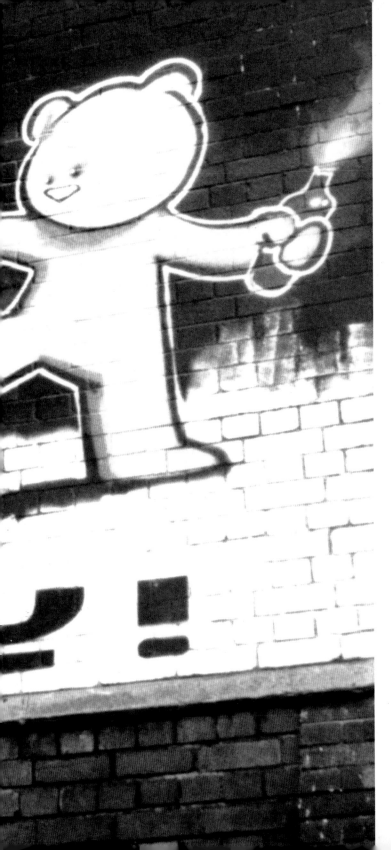

psychedelic references; punk was rising up in East Bristol's working class suburbs with the likes of Vice Squad and Onslaught, while the Cortinas put a more middle-class spin on it, and the boho-funk adventurists, led by Mark Stewart and the Pop Group, were holding court at the Lion pub in Cliftonwood. It would be an overly romantic notion to think that there was any great fusion between all these diverse expressions of urban culture, but there was certainly cross-over on a social level mainly between Stewart and The Wild Bunch who had a regular night at a club called the Dug Out on Park Row.

"So how does all this relate to the Mild Mild West? Who knows? But for people familiar with the Bristol scene at the time of riots, it kinda makes sense."

Bear essentials

The real story behind Mild Mild West, by Jim Paine – the man who got Banksy to do it

Jim Paine started out with a shop, Subway Records in Walcot Street, Bath, selling techno and hip hop records. He got that one decorated by Bristol graffer Feek. He opened a second Subway Records on Stokes Croft, Bristol in 1998. The shop also sold spray paint, and Jim later had the shop front decorated by TCF (Twentieth Century Frescoes, aka Paris, Eco, Xenz and Feek). He was also involved in the Bristol free party scene from 1993 to 2004.

"I knew Banksy from a while back, from the mid to late Nineties when he was sharing a house in Easton, a couple of streets from me. I was at a free party at a warehouse on Winterstoke Road, Ashton – the old HMSO building. This must have been New Year's Eve 1997/98. Free parties were basically unlicensed events where we broke in to a disused building. There were a lot of them at the time, in warehouses in Feeder Road, St Philips Marsh and Whitby Road in St Annes. But we also did legal club nights at Easton Community Centre, the Trinity, the Lakota, Club Loco and the old Leadworks [demolished to make way for the At-Bristol complex].

"Many of the crowd that night at Winterstoke Road were assaulted by the police, along with members of

the sound system who were playing. That party, in fact, marked the beginning of a more hardline approach from the police, using violence as a method of breaking up the parties. We were also getting chased and harassed a lot by the police at the time.

"Anyway, soon after I opened up the Bristol Subway shop, I told Banksy about this massive space on the wall of the building next door. The building was unoccupied at the time – it had been squatted, set fire to, abandoned and boarded up. I had access to the wall, and it just seemed like a great place for a big graffiti piece. He was really up for it. I got the ladder, we bought the paints between us.

"We discussed what the piece should be for about a fortnight. His first sketches had an anti-consumerist message. Banksy's first design had a building in flames, with a looter fleeing the inferno with a loaded shopping trolley. But then I started talking to him about the episode on Winterstoke Road. That was what gave him the idea for the piece.

"I said that, as far as social expression went, we felt pretty oppressed. We were pretty ordinary, fluffy, party people, and we were being bullied by police with riot shields and truncheons. The teddy bear was his idea. The idea of a teddy bear with a Molotov cocktail in his hand – it was showing that mix of hard and fluffy that, basically, was the free party scene. We were a pretty laid-back scene, but at the same time we were involved in things like the Poll Tax demos, Reclaim The Streets… it was a mixture of laid-back and quite fervent. We were also involved in the demos against the Criminal Justice Act. The free party scene in Bristol had a strong New-Age Traveller element, and they also had a history with the police. With the teddy and the Molotov motif, Banksy was saying, 'we could be one or the other. We'd prefer to be mellow, but…'

"I was surprised that there wasn't more reaction to the piece – police attention, angry letters to the *Evening Post*. After all, it's someone (OK, a teddy bear) chucking a petrol bomb at the police! I expected there to be all sorts of complaints of incitement to violence. Instead, it's been accepted into mainstream culture. And yet they complain about him writing his name on a bridge…

"Is it a reference to the St Paul's riots? I don't think so,

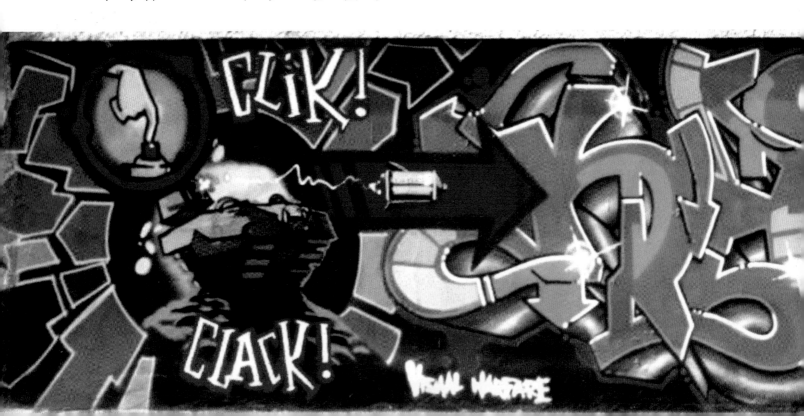

particularly. We certainly never mentioned it while we were talking about the piece. And the riots were a long, long time before that. So no, I don't think they were an inspiration – but then again, I'm sure he was thinking in a much wider context than I was.

How the West was done

"We did it in daylight, over three days. I held the ladder for him and kept lookout. The first day, he painted the wall black. Banksy used car paints – he had a deal with a guy who ran an auto shop. The next day he put the teddy bear in, and then the police. We did the cops last thing that day because that was the most provocative part. The third day, I think, he did the lettering. He wasn't happy with the coppers after doing his first draft, and if you look closely you'll see he's adjusted the outlines of the policemen. Banksy's a perfectionist. I love the way the teddy looks slightly wobbly, slightly ungainly… he looks kinda docile. It's a simple piece, but there's so much to read into it."

Below: Banksy's mural in Cato Street, Easton

Left: the mural after being defaced before the adjoining house was put up for sale. See over page for more.

VANDALS DEFACE BANKSY MURAL

Saturday April 28th

EVENING POST

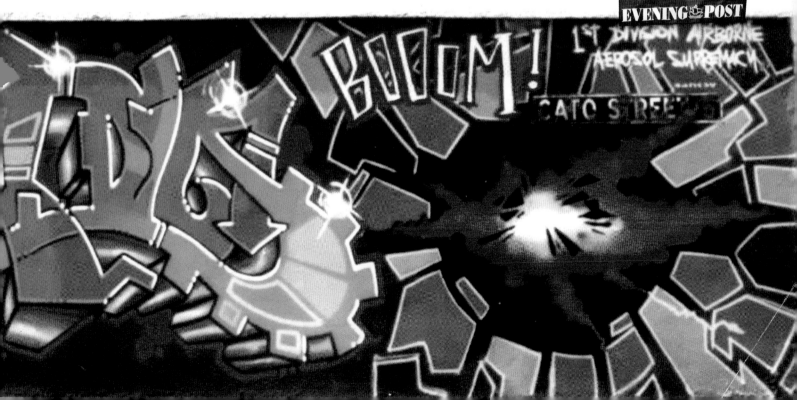

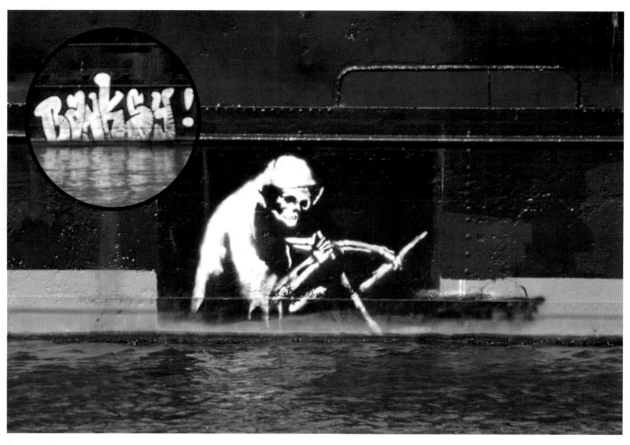

Banksy — not for sale

A Banksy mural on a house in Easton was deemed so valuable that it was advertised for sale as a Banksy piece with a house thrown in. The owners of 21 Mivart Street instructed an art gallery as well as the usual estate agents to seek buyers for the house. The owners were determined that the artwork should stay, and refused offers from buyers who planned to clean it off. The house was taken off the market after 'vandals' threw red and black paint over the artwork. A rumour even went around that Banksy himself might have defaced the piece – but we haven't found any confirmation for that one.

All in the same boat?

Banksy originally tagged the side of the Thekla floating nightclub in spring 2003. The Thekla owners posted a photo of the tag on their website and asked punters whether it should stay. Back came the response: keep it. But even as the votes were coming in, Bristol City Council ordered its removal. It was an interesting decision given that, later that summer, art installations were introduced around Bristol's docks as part of *Dialogue*, a public art event and part of Bristol's 2008 Capital of Culture bid. Thekla manager Joanna Jackson says the decision "Suggests that if it's an official installation it's art, but if it's unofficial it's not." Unperturbed, Banksy returned to paint the Grim Reaper in the same spot – this image remains, having survived the Thekla's refurb in 2006.

TCF Crew

If Nick Walker, 3D and Inkie's Crime Inc. were the first major graffiti crew to hit Bristol, a decade and a half later another crew began to make a huge impact in the city. TCF (Twentieth Century Frescoes) was actually formed in Hull in 1987 by graffers Xenz, Paris and Eko, who had all been painting together since leaving school in the city (the story behind the name is that Xenz had just returned from a trip to Venice and Florence, full of ideas for painting on walls). From 1996-98 the trio took root in Bristol, drawn by the city's already famous graffiti scene. By 2004, the crew was 10-strong, having added the likes of Feek, Ponk, Dicy and Ziml to its number. "I've always thought that crews need to be formed on friendships rather than similar painting practices," said Eko at the time. "I count my crew as some of my best friends."

For the last ten years they've given Bristol some of its most colourful, imaginative and distinctive spraycan art. For some of the best examples of their work, check out the phantasmagorical bread-inspired mural outside Herbert's Bakery, or Xenz and Paris's huge floral wilderness on the side of a house in St Werburgh's.

Production of The TCF Crew's work. Bottom pic: Production with The TDM Crew from Montpelier, France.

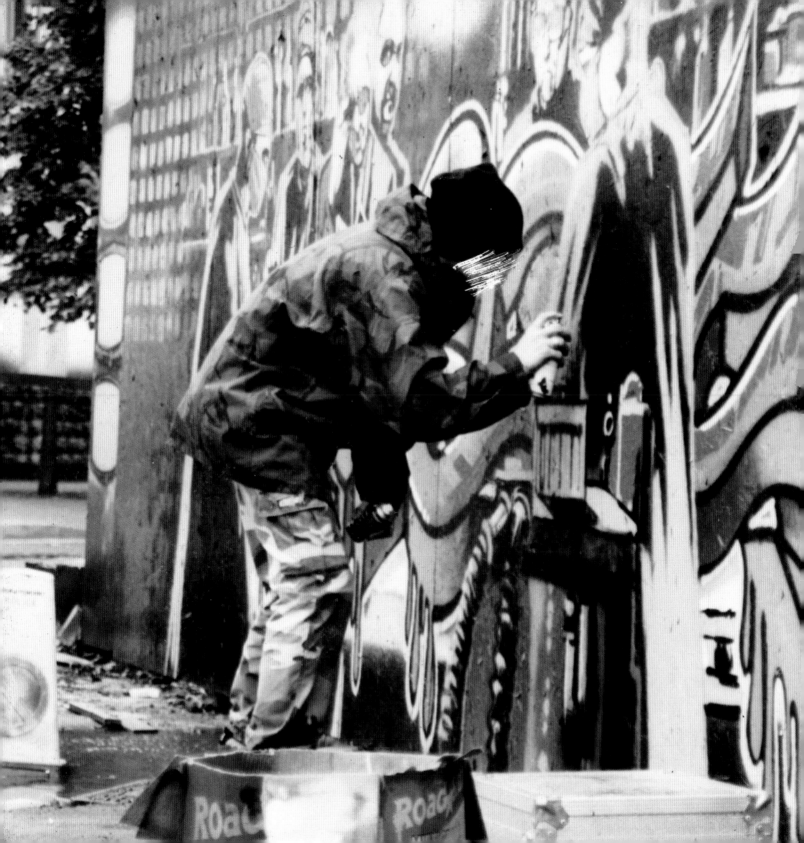

who is banksy?

We all love a mystery, and the swirl of myth and rumour that surrounds Banksy is actually far more exciting than a CV and a bald set of facts would be. Who was it that said that you should never meet your heroes, after all?

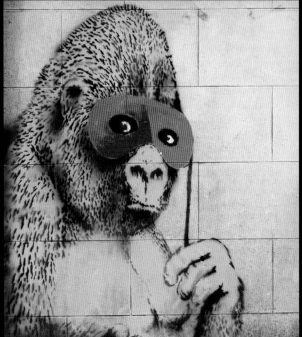

That said, what is Banksy actually like? "Down-to-earth, working-class, quite direct," says photographer Mark Simmons, who has worked with Banksy on several occasions. "Confident, cheeky, mischievous, maybe a little arrogant… but with a good heart."

Steve Symons worked at Time Bomb, a DJ and record promotion agency on Stokes Croft. "Banksy used to pop down to the office a lot. He was doing stuff in Bristol perhaps as far back as the Dug Out days in the mid-80s, and was friends with Inkie and 3D. He was just a really ordinary, working-class geezer. Totally solid bloke. The kind of anonymity that was necessary because of what he did – less so what he does now – suits him fine, because he likes to keep a low profile. He's got a very low threshold for bullshit from anyone. But he's a great game-player – he loves that whole mystique thing, but he also likes being ring-fenced from journalists and the media."

Gez Smith arrived at Bristol University in autumn 1997, and started seeing Banksys around Clifton that autumn. "I lived by the student union on Queens Road, and a couple of months after I arrived, I started seeing these huge Banksy logos – just his tag – all around that area. Then, over the next year, I started seeing his pictures all around town – Nipper the HMV dog in Park Place by the barbers, the clown with two guns down on Hotwell Road." He took dozens of photos of Banksys all around the centre, Clifton, Stokes Croft and Easton in 1999-2000, almost all of which have now disappeared.

Gez also worked, in 2000-2001, for Time Bomb. "I wish I'd asked them to pay me in Banksys, because there were quite a few around the office at the time." He remembers Banksy coming into the offices regularly. "He just seemed like a lot of other people at the time – easygoing, liked his clubbing, wore baggy jeans and T-shirts, he was quite tall."

"I've bumped into him a couple of times," says Ghostboy, another Bristol street artist who has been doing his stuff on the streets of Bristol for around eight years. "We've been painting in the same place a couple of times, coincidentally. I was asked by a mutual friend if I wanted to meet him, but it just felt a bit peculiar, a bit forced… we're in the same line, I appreciate his work.

"He's extremely focused and driven. A friend of mine has been out and worked with him in the past, and he says that Banksy doesn't hang out with the other graff artists, it's purely business to him. He's always had a very strong sense of his direction, knows exactly where he wants to go. That's unusual, in that other graff artists generally hang out together quite a lot."

"He's incredibly gifted and very observant," agrees Jim Paine, who held the ladder when Banksy painted Mild Mild West. "And sharp's just not the word for it! He's great at satire, in a real British tradition. He always sees the satirical side of things. His output's phenomenal – and, what's more amazing, everything he does is good. He's hugely

influential and successful. And very hard working."

So, what of Banksy's early life? According to Wikipedia: *Banksy is a well-known yet pseudo-anonymous English graffiti artist, possibly named Robert Banks. It is believed that Banksy is a native of Yate (near Bristol) who was born in 1974 but there is substantial public uncertainty about his identity and basic personal and biographical details.*

The name is wrong for a start. And Yate? Really?

Bear Hackenbush is a long-standing Bristol artist and illustrator, and a prominent figure on the 1980s skateboarding scene at Dame Emily Park, Bedminster. "I just remember skating down at Bedminster in the late 1980s, and having this kid called Banksy pointed out to me… I seem to remember he was tall. Then later, in

the early to mid Nineties, I remember covering up quite a lot of his stuff when I was flyposting and promoting club and gig nights. He'd be painting a lot at places like the Tropic Club on Stokes Croft and the Old England in Montpelier, and we'd go down sticking flyers over his stuff. I remember thinking, 'I like this guy's work a lot', but stuff on the street never had a very long shelf life!"

"When I first met him, which was probably in 1993, even then he was very driven," recalls one prominent Bristol graffer, friend and former collaborator of Banksy's. "He wasn't concerned much about what anyone else was doing – even though he was, back then, up for getting together and collaborating on projects and pieces, something he seems less likely to do these days. But he

already had that 'goal' then – wanting to get his message across, have that dig at the system, make that point.It seemed obvious then that he was going to become big or well known, he just had that air about him."

In an interview with the *Sunday Times* in October 2006, Banksy seemed to claim having achieved an E in GCSE art. A lack of inspiration, asked the interviewer? "That, plus I had also discovered cannabis." Another rumour runs that he was expelled from school and went to prison.

He seems to have been inspired by the street on which he grew up. "At the end was a giant billboard, and underneath it girls were doing tricks and cars were dumped. The billboard showed a toothpaste tube three times bigger than the houses, and none of the money from those adverts went back into the street," he said in the *Sunday Times* interview.

In 2005, Banksy told *Wired* magazine: "I always wanted to be a fireman, do something good for the world" and that he wanted to "show that money hasn't crushed the humanity out of everything." When asked by Bristol's *Venue* magazine when he had first picked up a spraycan, he answered: "The day someone ram-raided the Halfords round the corner from our house about ten years ago."

And, lastly, why the move to stencilling? Banksy started out as a freehand graffiti artist, but – he tells the tale in his book *Wall and Piece* (Century) – had something of an epiphany one night while painting trains with a group of other artists.

When I was eighteen, I spent one night trying to paint 'LATE AGAIN' in big silver bubble letters on the side of a passenger train. British transport police showed up and I got ripped to shreds running away through a thorny bush. The rest of my mates made it to the car and disappeared so I spent over an hour hidden under a dumper truck with engine oil leaking all over me.

As I lay there listening to the cops on the tracks, I realised I had to cut my painting time in half or give up altogether. I was staring straight up at the stencilled plate on the bottom of a fuel tank when I realised I could just copy that style and make each letter three feet high.

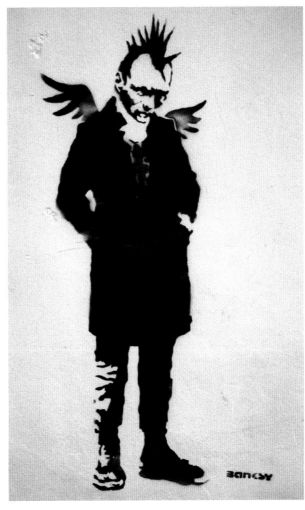

This piece above the phone boxes on the Hippodrome side of the Centre only lasted three days.

Fire starter

Feisal Khalif helped organise the 1998 *Walls on Fire* festival with Banksy and others
"The graffiti festival was commissioned by At-Bristol following lengthy proposals by Banksy and his colleagues. I was the temporary public art project manager during the planning stage, as well as being At-Bristol's marketing manager. The project was partly designed to enable At-Bristol to communicate the ethos of the future millennium project (a fusion of science, art and nature) and partly as a practical way of decorating the ❱❱

1974

1974
Born in Bristol area.

1992-94
Banksy's graffiti, both freehand and stencil, starts appearing on trains and walls around Bristol.

July 1998
Paints a piece beside the main stage at St Paul's Carnival.

August 1998
Collaborates with Inkie and others for the *Walls on Fire* graffiti festival at Bristol Harbourside, in which leading graffers paint on the hoardings around the future At-Bristol site. Banksy's pieces are said by many to be among the best at the festival – but they're stolen shortly after.

1999
Banksy, Inkie and Mode2 paint Take The Money and Run mural, opposite the Old England pub in Montpelier, Bristol. The piece is still there.

Early 1999
Mild Mild West goes up on Stokes Croft.

July 1999
Spraypaints van at Ashton Court Festival

Late 1999
Leaves Bristol for London.

January 2000
Back to Bristol, to decorate the casket of local club legend Lez Hutchinson.

February-April 2000
Solo show at Severnshed restaurant with the theme, he tells *Venue* magazine, of 'punk fuckin' rock'. All but three of his paintings, priced from £89 to £2,000, sold on the first day.

2000
Collaborates with artist Paul Insect on artwork for the *Do Community Service* LP by Bristol trip hop outfit Monk & Canatella (this image is shown on page 65).

Octotber 2000
Exhibits at urban clothes shop Alterior, Park Street, Bristol. His paintings, which fetch prices between £150 and £899, are bought within three days of going on display. "I put his work up on the Saturday of the Ashton Court festival because the shop was so quiet and by Tuesday I had sold the whole lot, " says Alterior's Justin McCarthy.

February 2001
Sprays (legitimately) the walls of the Swiss Embassy, London.

2001
First (unofficial) London exhibition, spraypainting 12 works of art including Riot and Tiger Economics (see page 56) onto the whitewashed walls of a tunnel at Rivington Street, Shoreditch, above the title Speak Softly. But Carry a Big Can of Paint.

Summer 2002
A Banksy stencil – featuring a rat smoking a cigarette and holding a shovel – is given away free with *Bizarre* magazine.

July 2002
Does artwork for St Paul's carnival again.

September 2002
Shows at a London exhibition presenting an alternative view of the Queen's Golden Jubilee, alongside Throbbing Gristle's Genesis P-Orridge and Jamie Reid, sleeve-designer for the Sex Pistols. "At once calling for the abolition of the monarch, this show and gallery celebrate the spirit of punk, of bondage, of do-it-yourself cut and paste cultures that create opposition and will not tolerate conformity and the status quo," says a spokesman for the show.

April 2003
The e-zine www.bristolbeat.co.uk publishes an online tour of Bristol's Banksys.

May 2003
Hands out signs reading 'I Don't Believe In Anything. I'm Just Here For The Violence' at a May Day demonstration, London.

May 2003
Banksy tags the side of the Thekla floating nightclub. On the Thekla website, customers vote overwhelmingly to keep it, but Bristol City Council paints over it – graffiti is seen as detrimental to the harbourside's image. Banksy returns to the same place soon after, and stencils an image of the Grim Reaper in a little jollyboat – the image remains to this day.

July 2003
Spraypaints animals from a farm in Somerset, for the exhibition Turf War in

Shoreditch, London. The show includes a cow covered in Warhol portraits, sheep stencilled with the striped pyjamas of Holocaust victims and a pig bearing the chequered stripes of the Metropolitan Police. Animal rights activist Debbie Young chains herself to railings surrounding a Warhol cow. "The cattle are show cattle donated by a farmer and he was happy to lend them," says a spokeswoman for the exhibition. "The RSPCA and the council checked it all out and they think it is fine to have the animals in the exhibition – if a little unusual." The exhibition is later called off because hot weather is distressing the animals.

October 2003
Slips into Tate Britain and glues a painting – a pastoral scene with police incident tape painted over it – to the wall. Only discovered when it crashes to the floor later.

November 2003
Seen at the demonstration against the Iraq War that culminates at Trafalgar Square. Banksy hands out flyers that read 'Warning: Americans Working

Overhead', with his helicopter stencil.

January 2004
Advertising industry journal *Campaign* reports that Charles Saatchi is a big Banksy fan. Banksy's riposte: "I wouldn't knowingly sell a painting to Saatchi."

April 2004
Banksy, disguised as a museum employee, smuggles a dead rat in a glass-fronted box into the Natural History Museum, London. The rat wears wraparound sunglasses and carries a rucksack, a microphone and a miniature spraycan. And it's just sprayed, on the wall behind it, the message 'Our time will come.'

April 2004
He's being hunted by police after a large 'Banksy' tag is painted onto a railway bridge over the M32 in Easton, Bristol, causing a £20,000 cleanup bill. Banksy originally denies doing the piece. In a statement faxed to the Bristol *Evening Post*, he says: "I am shocked and saddened to see my name being used in vain on the M32 train bridge. The painting, which

appears to say 'Bonsky', is not something I would want to put my name to. The lettering is not in proportion or even straight. "I take my job as a professional vandal extremely seriously and consider this to be an inferior piece of work. I wish the relevant authorities all the best in returning the bridge to its former flat, grey, colour." Despite his denials, the piece features in Banksy's book *Wall and Piece*. "The M32 bridge was definitely him," confirms an (anonymous) Bristol graffer and close Banksy associate. "He told me he was well pissed, so was pretty embarrassed by it!"

2004-2005
Bristol's *Greenleaf* Bookshop is selling nearly all of Banksy's signed prints for around £40-£80. The same pieces would, in 2007, be fetching several thousand pounds.

July 2004
Beyond Banksy exhibition at Northern Lights gallery, Bristol. Includes work by Nick Walker and Ghostboy.

July 2004
The *Evening Post* 'reveals'

Banksy's identity. In fact, it's a picture of a man in a balaclava, and beside it the paper says that Banksy is 'thought to be 28' and that his 'real name is understood to be Robert Banks'.

March 2005
Enters, and hangs his work in, four world-famous New York museums and art galleries (Museum of Modern Art, Metropolitan Museum of Art, Brooklyn Museum, American Museum of Natural History). "This historic occasion has less to do with finally being embraced by the fine-art establishment and is more about the judicious use of a fake beard and some high-strength glue," Banksy comments to the graffiti website www. woostercollective.com "I've wandered round a lot of art galleries thinking 'I could have done that', so it seemed only right that I should try. These galleries are just trophy cabinets for a handful of millionaires. The public never has any real say in what art they see."

May 2005
Another museum infiltration – this time at

the British Museum, where he places a cave painting of a primitive man pushing a supermarket trolley. The piece is entitled Early Man Goes to Market, and captioned 'This finely preserved example of primitive art dates from the Post-Catatonic era and is thought to depict early man venturing towards the out-of-town hunting grounds. 'The artist responsible is known to have created a substantial body of work across the South East of England under the moniker Banksymus Maximus, but little else is known about him.' The British Museum adds the piece to its permanent collection.

May/June 2005
On the strength of his recent museum incursions, Banksy is put forward by the public (though later not shortlisted) for the Turner Prize.

June 2005
Sticks a shark's fin among the mudslides at Glastonbury Festival.

August 2005
Decorates the West Bank segregation wall in Palestine with various scenes including a trompe-l'oeil of a hole in the concrete barrier, revealing an idyllic, unspoilt tropical beach on the other side.

June 2005
Banksy is nominated for the South Bank Show Awards, but loses out to landscape painter John Virtue.

October 2005
New exhibition Crude Oils features 200 live rats, plus 20 versions of classic oil paintings, retouched in Banksy's distinctive style. The rats are allowed to run free around the gallery at 100 Westbourne Grove, London.

June 2006
Paints the famous window-hanging nude lover mural on Frogmore Street, Bristol.

July 2006
The Frogmore Street piece is allowed to stay after overwhelming support from people in the city. Nearly 500 Bristolians respond to the council survey, with 97 per cent voting to keep it.

July 2006
While in London, Christina Aguilera pays a huge £25,000 for a Banksy painting depicting Queen Victoria in a lesbian act.

August 2006
Spraypaints his signature on five pigs on a farm near Glastonbury, which are to appear in Pig Boy, a comedy horror film by a Glastonbury-based film company. Farmer Andrew Wear: "I think that it is great. The pigs do not seem to have noticed much."

August/September 2006
Banksy swaps copies of Paris Hilton's latest CD with his own fake version, featuring his own takes of her music and new cover artwork. Hilton appears topless on the cover; the amended song titles include Why Am I Famous? and What Am I For?'

September 2006
Dresses an inflatable doll as a Guantanamo Bay prisoner and places it within the Big Thunder Mountain Railroad ride at the Disneyland theme park, California. The piece remains for 90 minutes before the ride is halted and the figure pulled down. A spokeswoman for Banksy confirms that the stunt is intended to highlight the detention of terror suspects at the controversial camp in Cuba.

September 2006
A wall on Sevier Street, St Werburgh's, Bristol, featuring a mural by Banksy (and others) is torn down to make way for flats. A block from the mural with Banksy's signature is auctioned on eBay, fetching more than £400.

September 2006
Barely Legal exhibition in LA, featuring live 'elephant in the room'. Brad Pitt, Angelina Jolie, Jude Law, Keanu Reeves and Joni Mitchell are in attendance at the VIP preview. Jolie spends £200,000 on three pieces, including a portrait of a man hit on the head with a custard pie.

December 2006
Banksy's new print Flag goes on sale at Workshop, Park Row, Bristol, at £100. Only one print per person. Proceeds of the sale go to Sightsavers International, an international charity working to combat blindness in developing countries. The 100 prints sell out within two hours.

February 2007
Easton, Bristol: Owners of a house with a Banksy mural on the side decide to sell the house through an art gallery, after offers fall through because the prospective buyers want to remove the mural. The house is then listed for sale as a mural with a house attached. The mural itself is later defaced and the house withdrawn from the market.

March 2007
An early, freehand Banksy is painted over by Council graffiti-removal contractors in Albion Road, Easton.

April 2007
Familiar stencil of a cut-out coupon appears off the Triangle, Clifton. Later removed because the Council doesn't think it's a Banksy.

April 2007
A new Banksy record is set: £288,000 for Space Girl and Bird, at Bonhams.

May 2007
Gains the award for Art's Greatest Living Briton (ITV, *Greatest Britons 2007*), beating Antony Gormley and Sam Mendes. Other winners: David Beckham, Ricky Gervais, Amy Winehouse, Dame Helen Mirren, the Queen. Banksy doesn't turn up to accept his gong.

May 2007
Banksy's iconic Mild Mild West mural in Stokes Croft wins BBC Radio Bristol's public poll to find an Alternative Landmark for the city. The mural gets 47% – more than double its nearest rival, the old industrial chimney stack at Troopers Hill in St George.

June 2007
Banksy erects his 'Boghenge' sculpture at Glastonbury Festival. The piece features several portable chemical toilets piled on top of each other, Stonehenge-fashion. A statement from Banksy said: "A lot of monuments can be a bit rubbish. But this really is a pile of crap." 54 per cent of voters to a poll at www.efestivals.co.uk judge the piece 'bad'. A spokesman for the festival says: "The Henge will come down at some point but it still belongs to Banksy and it will then be up to him to decide what he wants to do with it."

June 2007
A YouGov poll to find arts heroes among the under-25s puts Banksy third, after Walt Disney and Peter Kay but ahead of Leonardo da Vinci.

October 2007
Banksy features, for the first time, in the uber-prestigious Evening Sale at Sotheby's.

October 2007
Returns to Bristol to paint a piece opposite the Children's Hospital. The image shows a police marksman preparing to fire, with a small child behind him about to burst a paper bag next to his head.

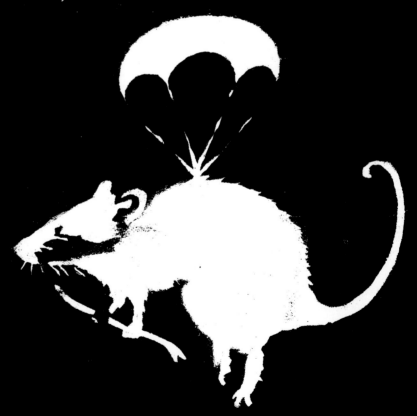

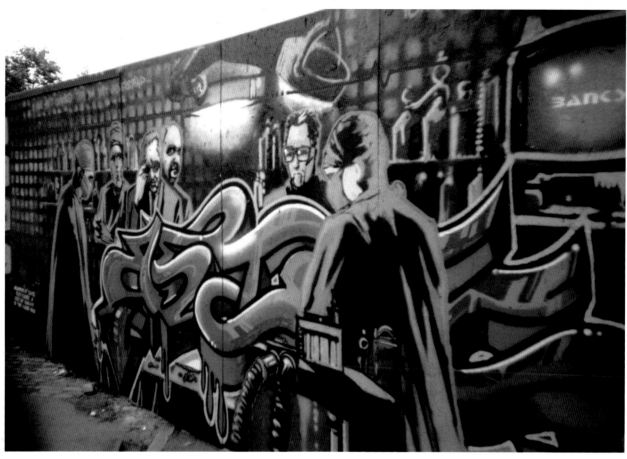

▶▶ hoardings that surrounded the building work. The basic principle guiding the graffiti was that any work displayed must adhere to the themes of 'science, nature and art'. As, frankly, these are themes that govern virtually all known human activity, it meant pretty much anything was allowed. This therefore neatly avoided having to attempt to square the philosophy of most graffiti writers (certainly at the time) with the idea that their work might be prescribed, edited or censored.

"Banksy and all the graffiti artists I encountered were fantastic to deal with – committed, personable and streetwise. This was particularly evident in the early planning stages when the event was by no means guaranteed to happen. The event itself was pretty much self-regulating and a huge success."

Inkie and Banksy were among the stars of the show; *Venue* magazine put Banksy on the cover to trail the festival. "If you want to say something, you have to put your message up where people can see it," he tells *Venue's* John Mitchell. "It's about putting your neck on the line and putting the effort in to create something; about having the energy and guts to see it through. Easton's an area which is on the way up and my work celebrates that. I paint hard for Easton and if every area had someone painting hard for it, the country would be a far more colourful place."

Jim Paine of Subway Records adds: "Banksy organised the whole event: the artists' roster, who was painting where and when, but also the sound system and DJs. His piece was the best, and was nicked days later."

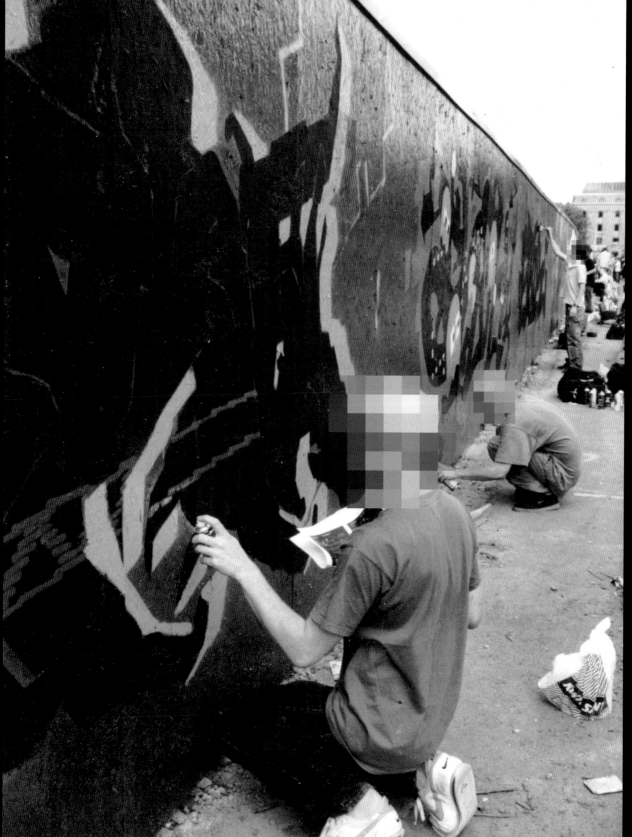

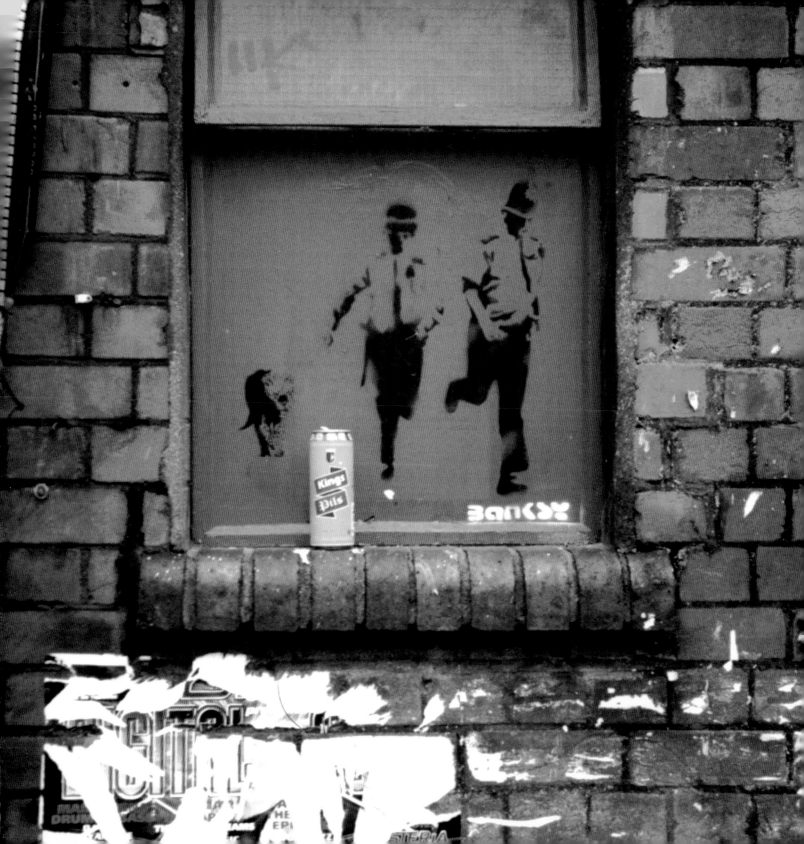

Severnshed, 2000

Banksy put on his first major solo show at Severnshed restaurant in Bristol from February to April 2000. He had recently left the city for London, but returned with a variety of designs including his Self Portrait (with chimp's head) and the flower-toting rioter. Artist and designer Robert Birse curated the Severnshed show with Banksy.

"I had been curating shows at Severnshed for a while, and leapt at the chance of doing a show of his work. I'd been a massive fan since first seeing his work when I came to art college in Bristol in 1995. I remember seeing his rats on Park Street and being hugely intrigued, both by the art and the guerrilla tactics of whoever was doing it. He took a strong role in all aspects of the show – he's a man who knows what he wants. He had very strong ideas of how pieces should be hung, what the feel of the exhibition was to be. He also did all his own flyering for the show. He's a very strong-willed guy – not in an overpowering, aggressive sense , he just knew exactly what he wanted. And because of that he was a pleasure to work with.

"I was never in any doubt that, as soon as he made the decision to start exhibiting in a saleable format as well as on the street, he would go a long way. It was clear he had the intelligence and the ability to be huge in the art world. And he's a great self-publicist, there's no one else like him. The work sold out on opening night. I did not buy any, but I was given one of an edition of ten as a 'thank you'. It was one-in-one-out at the venue pretty much from opening time. During the day before the opening night, we had a sort of preview. Lots of people came down and wanted to buy a piece, but we were both adamant that nothing was going on sale until the exhibition started, that we wanted it to be completely democratic, first-come-first-served. I had to say no to [Massive Attack's] Daddy G who wanted to buy one before opening – he was not chuffed! We had a call during that day from the head of Avon and Somerset Police, who asked me if I would approach Banksy for a get-together with the police. They just wanted to have a nice chat with Banksy, and encourage him to move away from the street graffiti, maybe take a different tack. When I told Banksy about the call he just laughed his head off."

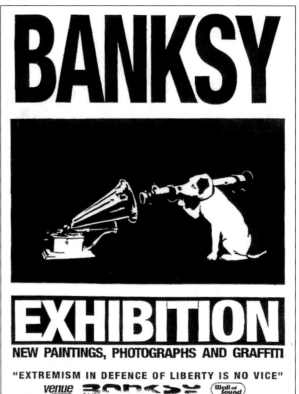

Paul Kelly

Paul Kelly is a seminal, if elusive, figure in the Banksy story. A 'representative' for the emerging artist, he pushed his protégé hard in the early years. He was also a peripatetic but vital part of the 1990s Bristol scene – and something of a character. Carlton Romaine recalls that Kelly and Banksy approached him when Romaine was one of the organisers of the St Paul's Carnival, in 1998, to arrange for the artist to do a large freestyle graffiti piece on the side of Valentine's, a late night music bar, for that year's Carnival.

"Paul was pushing Banksy everywhere, trying to get him involved in whatever was going on in Bristol. Paul was quite an elusive person, you wouldn't see him for months at a time, but every time I'd run into him, he'd mention Banksy to me, and try to push Banksy at every opportunity. He was always trying to flog a Banksy to me, too…"

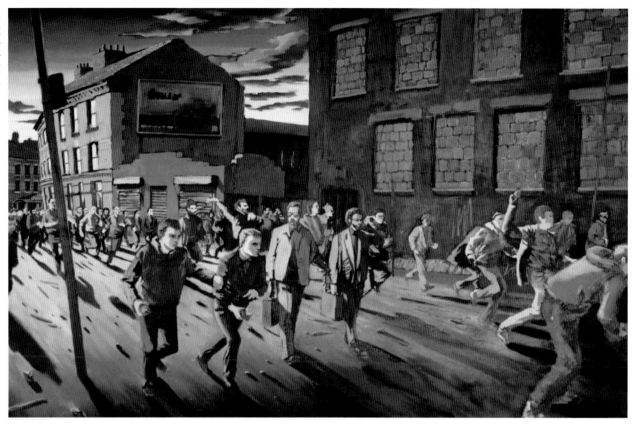

Friends with Massive Attack's Daddy G and others, Kelly was, as Romaine puts it, "a kind of freelance promoter/hermit/maverick" on Bristol's music, club and art scenes.

"He took up Banksy's cause right at the beginning, and was definitely partly responsible for getting his name around Bristol. But with Paul, it was always about the art, the street, and freedom of expression. Art had to stay true to the street. In a way, he's more real than Banksy, in that he has always kept it real. It was always about the art and the music and never about the money, to the point where he was living hand-to-mouth, crashing on people's floors, trying to do his stuff. He's real. He believes in it all the way, in ways that perhaps Banksy doesn't, or doesn't anymore."

Richard Jones, who was the *Bristol Evening Post's* music writer at the time remembers: "Paul ran a barber's shop on Stapleton Road called *Kelly's*, and was well-known for cutting Batman logos and the likes into kids' hair, so it usually had loads of kids in there getting some street cred logo on their bonces. He did a mean flat top as well. It was a real characterful place with a few old West Indian guys hanging out and loads of banter.

"Paul always claimed he had interest from EMI for a band he looked after called The Spasmodics, but EMI signed a band from Oxford called Radiohead instead. The last time I saw Paul, he was going on about this artist called Banksy he was helping out and how Banksy was going to paint something on the side of his house in Chapel Road in Easton in a special paint that only showed up with UV light or something. It was probably nonsense, but raises the question of whether there is an invisible Banksy in Easton."

We couldn't find Paul for an interview, but understand he has left Bristol to return to his home town of Liverpool.

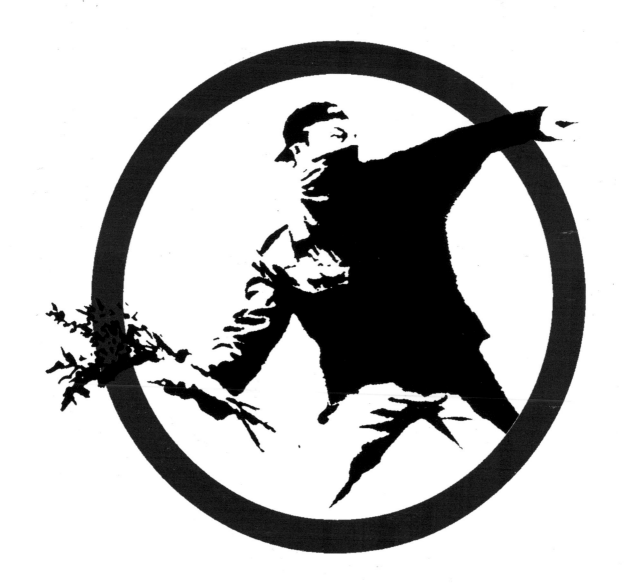

KEEP LEFT

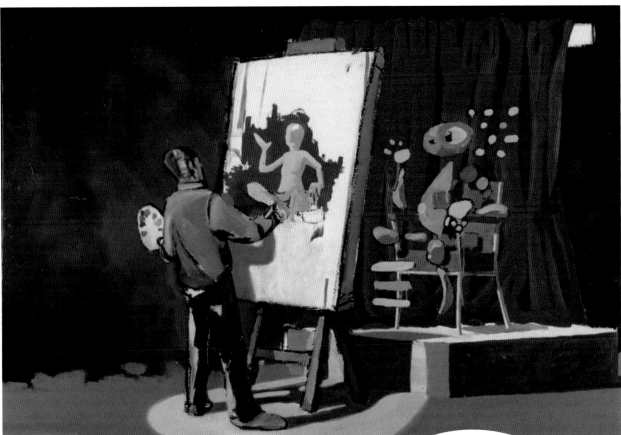

More shots
from the
Easton
exhibition
and a Banksy
sticker.

Sweet charity

In 2006, Banksy fans queued for three hours outside the Workshop store in Perry Road, Bristol. The reason? His new print, Flag, went on sale at £100. Proceeds were given to Sightsavers International, a charity working to combat blindness in developing countries, restoring sight through specialist treatment and eye care.

"There was a note on the back of them encouraging anyone re-selling the print to contribute a proportion of the revenue to Sightsavers. The print went on sale in the Workshop store in Bristol and at Santa's Grotto, a temporary exhibition of his work in London," said Ann Noon, Sightsavers' Media Manager. The prints sold out at Workshop within two hours.

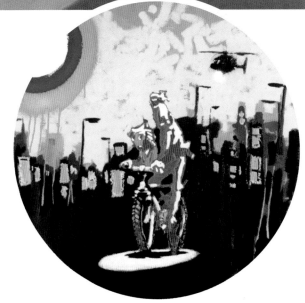

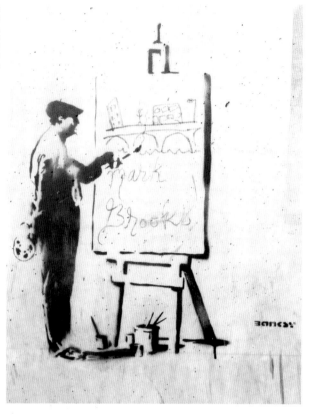

there's such a culture of competitiveness, people paying ever higher prices for the cachet of owning a Banksy, which stops real people owning one."

Yes, Banksy's left Bristol – but he's left a lot of random people with a nice little nest egg – people that have bought sketches of his at Greenleaf Bookshop or at various small shows around town over the years. That's a very Banksy kind of thing to do.

Bristol Artist Will Brown was one of the early admirers of Banksy's art

"I saw an early Banksy stencil (Heavy Weaponary) in Stokes Croft in 1998 and was so intrigued, I started systematically photographing graffiti – I have a collection of about 2,000 images. I went to Banksy's exhibition at the Severnshed when he left for London and bought one of the limited edition of 10 canvasses of Heavy Weaponry for £100. I sold it in 2007 for £24,000.

"Banksy is interesting to me because he has become a successful artist without interesting or appealing to the art intelligentsia or academy. His pictures rarely refer to other art or the art world. They are not complex or difficult to 'get' so they don't confer on the viewer the pleasure of being in a select club of the artistically literate who are able to 'read' them.

"Banksy's work is always political and his political concerns reflect those of contemporary British counter culture (animal rights and exploitation, hi-tech policing and surveillance etc) which interest me. Banksy's persona takes further the 20th century concern with the life and spectacle of the artist in relation to his own work – this strand goes through Van Gogh, Jackson Pollock, Warhol etc. Banksy is the artist who is so famous he is unknown."

My Banksy

Gez Smith went to the Severnshed show in Feb 2000 and picked up a Banksy with his student loan

I was first through the door, so I went around taking my pick. I ended up paying £300 of my student loan for Riot Green. There were other pieces there, including his Self Portrait [with a chimp's head that sold recently at Bonhams for £198,000]. Nothing there was selling for over £1,000, and most of it was around £150-£500.

"When I decided to see how much it was now worth. Sotheby's quoted me £30,000 – it ended up selling for £78,000. I drove it up to London in a Pieminister van.

"The current prices are bonkers. The bubble will burst. The contemporary art market is in a massive bubble at the minute. Generally that bubble collapses about two years after the housing market collapses. What is a shame is that

A woman from Totterdown, who refers to herself as 'Lucky Bugger' was also at the Severnshed show

"The title of the piece I bought is Heavy Weaponary (yeah, that's how it's spelt on the piece). It's an elephant with a nuclear missile on its back and over-stencilled with the words London, New York and Bristol. London and New

Banksy
meets Brunel
at Clifton
Suspension
Bridge.

ISBN

0100

HEAVY ★★★ WEAPONARY

BANCSY

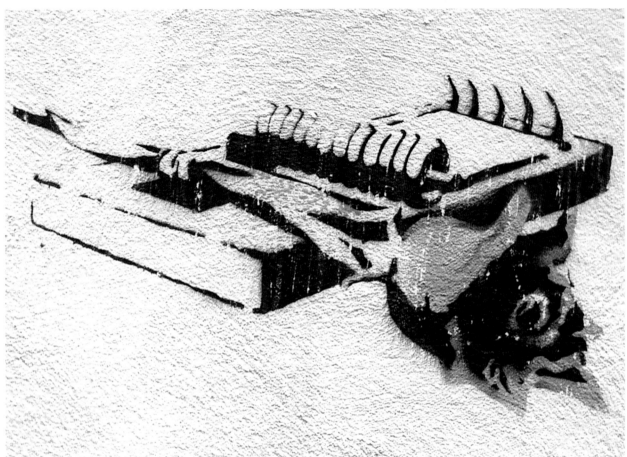

That page:
Heavy
Weaponary
stencil in
Stokes Croft.
Canvas
originals of
this image from
the Severnshed
show now sell
for more than
£25,000.

This page:
Banksy the
Romantic.

York are heavily crossed out in crayon. It's paint on board with an unfinished oil piece on the reverse. I bought it at the Severnshed exhibition for £150 and sold it in 2007 for more than £30,000

"I'd seen Banksy's stuff on walls all over Bristol in the late Nineties and they'd always made me grin. So when he had his first exhibition at the Severnshed I wanted to support him and also buy a bit of the city I love.

"I liked the flower-flinging rioters pieces but chose this one because it seemed to say you don't have to move to capital cities to get creative recognition and that basically Bristol rocks! I interpreted the lumbering elephant carrying a bomb as a wake up call to slow down.

"The reverse had a strange unfinished oil painting with a character sitting in a hanging cage wistfully staring at an out-of-reach key – it was really dark and used to give me goose bumps. I decided to sell the piece when I heard of the crazy figures being paid for his work in LA (there's a reason they call it lala land)… and I'm just as happy now to have a digital copy hanging on my wall.

"All power to Banksy and the madness of fashionistas!"

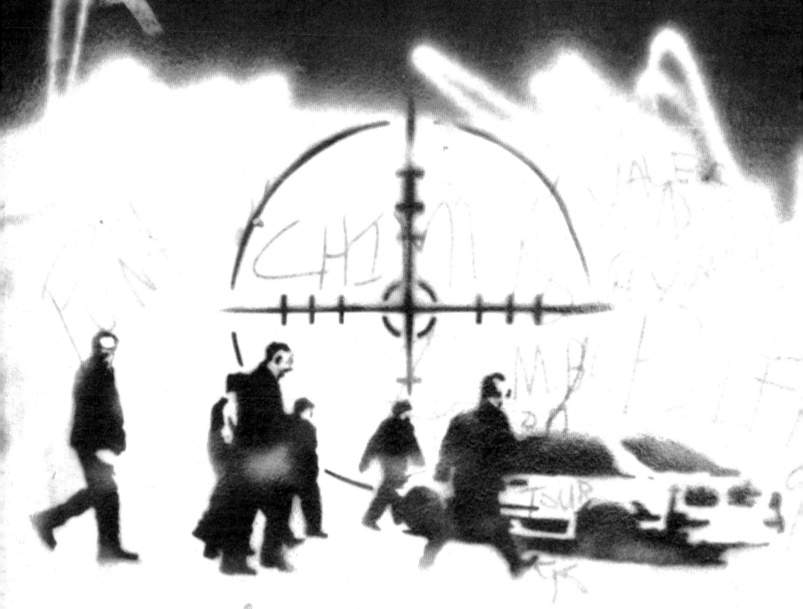

crest of a rave

Bristol photographer Matthew Smith was heavily involved in the early Nineties rave culture, and events such as the huge demos against the 1994 Criminal Justice and Public Order Bill – introduced, as he puts it, "to outlaw dancing together in the open air and to criminalise the travelling lifestyle."

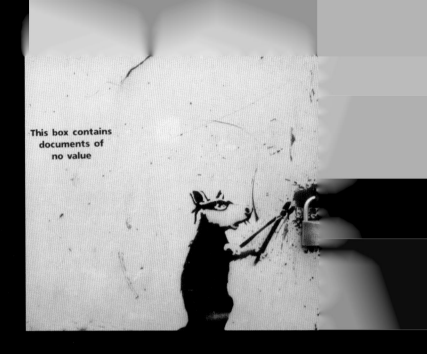

This box contains documents of no value

"I first met Banksy (although he wasn't using that name then) in Bristol in 1995, when we were part of the organisation behind a huge free festival called *The Mother* which was meant to happen in Devon. The festival was to mark the first anniversary of opposition to the 1994 Criminal Justice Bill.

"I was part of Sunnyside, a sound system which we'd taken on the huge and peaceful demos against the Criminal Justice Act on Mayday and on 23rd July 1994. We'd also been part of a nationwide tour called *The Velvet Revolution*, to mark the passing of the Criminal Justice Act and to raise awareness about its implications for civil liberties. It was funded by Liberty, Charter 88 and The Levellers. We were doing a lot of free parties around that time from a warehouse under Feeder Road – I remember a crowd of about 15,000 from all over the country coming to one of them. I shared a house with a few of the people involved in our crew in Bruton Place, Clifton, and while we were waiting to head down to Devon for the festival a sound system came down in their truck and parked up outside. I remember a Banksy stencil going up in Bruton Place then – and I think it was one of Nipper the HMV dog with the 'keep back 200 feet' thing going on, but it may have been later...

"Banksy just hit all the DIY social and political ideals of that time right on the head – the idea of music as a social weapon, music crossing boundaries and creating communities in a way that felt threatening to those in power at the time. NVDA (or non-violent direct action) was one of the buzz words of the time, and graffiti is just that: creative peaceful protest. It's about one person's voice being able to make a difference, especially if you

are visually literate and incisive enough to catch the public imagination. Banksy is at his most successful as an interventionist and his sense of place and situation is brilliant. That said, I do think part of his contemporary success is down in no small way to some very clever niche networking since moving up to London – and the help of some highly commercial and cynical art marketeers.

"The whole London thing is crucial. It's sad, but he would never have become the success he has if he hadn't left Bristol and got his work on the walls of the city that houses all the creative heads of state, most of whom are far too complacent to leave the capital for any length of time. Spraying around Soho, Hoxton and the East End is a great way to become instantly trendy, as long as you have the product. If the mountain won't go to Mohammed...

"The dance music and festival scene wasn't the huge in-house industry it is now. It was all about word of mouth, people deciding to be in the same place at the same time, and to take the consequences if necessary. Festivals and free parties were funding and publicising the traveller lifestyle in a massive way, and the government was desperate to prevent this.

"Early rave culture was hugely democratic. It also had a tremendous sense of community, far more than there is now, and it was regarded by the authorities as

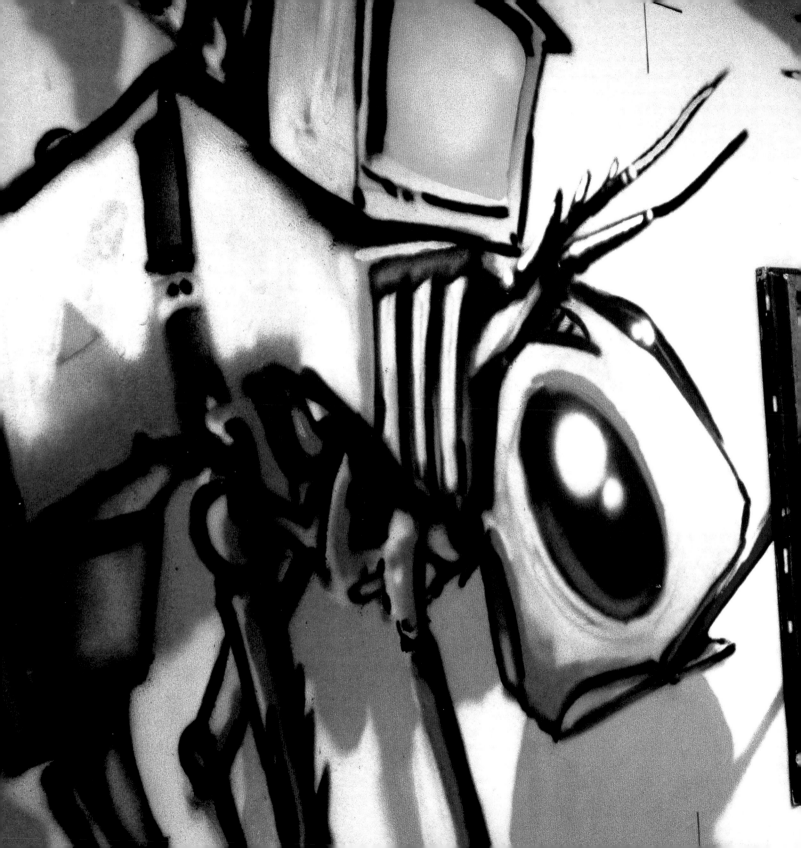

A Banksy
original in
the Pierced Up
tattoo parlour.

extremely dangerous. Even punk, which was the first mass music subculture to really challenge and say 'fuck you' to authority, never aroused the interest of the government to such an extent that it actually got off its arse to find an excuse to legislate against it.

"Operation Snapshot was set up around that time: an intelligence-gathering exercise on raves and Travellers, designed to establish a database of personal details, names, nicknames, vehicle registration numbers, Traveller sites and movements. It was basically an initiative to stop people meeting in public places, to stop them building any kind of community – however temporary. It was the beginning of our surveillance society – a lot of people working with us had their phones bugged, some people working with us in London had been busted by MI5.

"Lots of people were realising that an independent media was the only way to get real social messages across. I think that's one of the great beauties of graffiti: it's public information, unedited and straight from the heart – something that never happens in the conventional mass media. I think that's where a lot of Banksy's anti-authoritarian politics may have come from."

Many of Banksy's pieces are cheeky and defiant – they thumb their noses at authority and urge us not to swallow the usual lines fed us by politicians and big business. And it may be that this wised-up defiance simply rings truer with people in today's more guarded, cynical society than it might have done ten years ago.

"His ideas are striking a real chord with people now," adds Smith. "Five or ten tears ago, it sounded naive to talk about conspiracy theories, to suggest that the government might not necessarily have your best interests at heart. But ever since the Iraq War, the fudged justification for that war and the charade it's been ever since, I think a lot of Banksy's messages are having as lot more resonance. People are more receptive to his ideas."

There's All This Noise...

A particularly thought-provoking Banksy piece (painted with Lokea) commenting on the media was There's All This Noise which was on the side of a building at the Redcliffe end of Welsh Back, but has long-since gone. "It's one of my favourite Banksys – it pretty much sums up most of TV and the media," says Mark Simmons. "The endless, vacuous chatter, how it sucks you in and drains your spirit. It reminds me of a quote I once heard, that as long as you provide the people with enough well-produced light entertainment as a distraction, they won't rebel.

"The thing about Banksy is that he's taken something accessible to all – street art, and with his flair and determination and imagination, has taken it to another level. He's democratised art, made it more accessible – but the irony is that the art world, by pushing up his prices, has hi-jacked that accessibility."

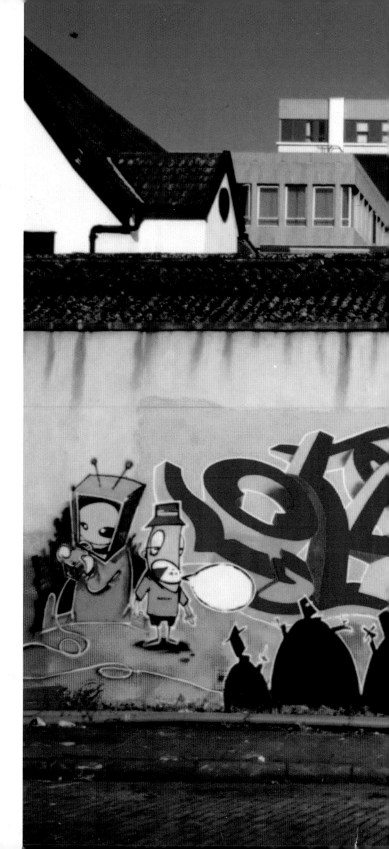

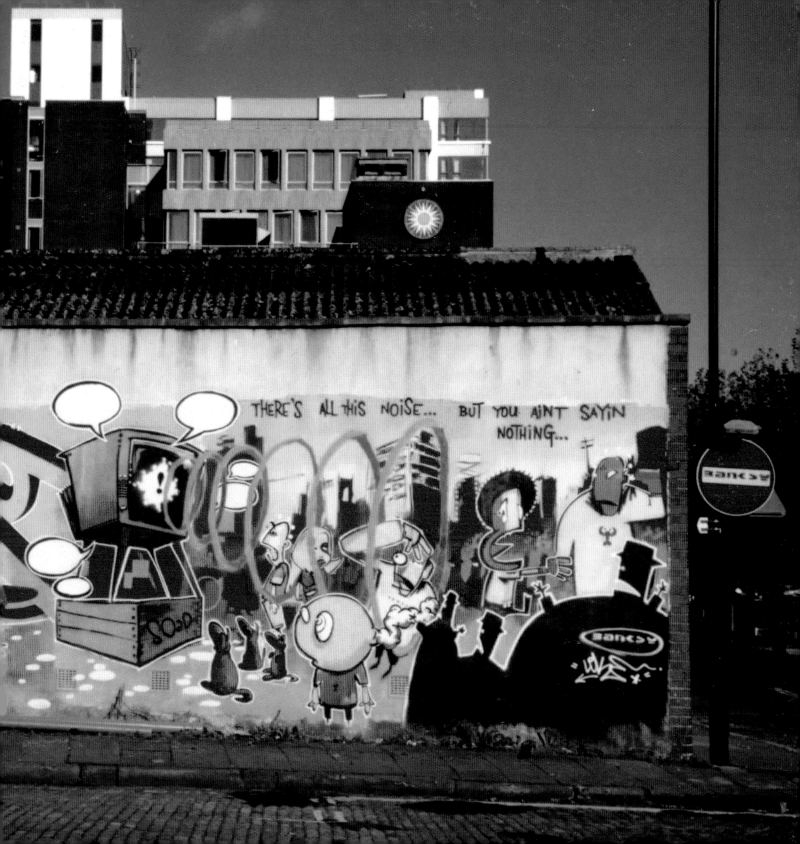

Christmas spirit?

December 2003: Phone giants Orange sponsor a Christmas show in which artists' work is projected onto London's landmarks at night. But Orange censor two pieces of work – one a depiction of the Virgin Mary, her face replaced with a globe and her halo replaced with a peace sign. The other is Banksy's depiction of Jesus, with arms outstretched and weighed down with bags of shopping. "This could have been the most poignant and relevant representation of Christmas for our modern times," laments one observer.

This page: Protestors at an anti-war demo in London with Banksy placards.

That page: Banksy's home-made Christmas card.

The subvertisers

Bristol is the spiritual home of subvertising, a movement with which Banksy has much in common. Subvertising is the practice of altering billboard adverts with often witty, often angry slogans (anti-war, anti-capitalism and, of course, anti-advertising itself). This form shares a lot, of course, with street art, with stencil art especially, and with Banksy's own particular brand perhaps most of all.

Like the stencillers, the subvertisers meticulously prepare their artwork before spending a few minutes mounting it over the billboard; also, like some of Banksy's pastiches of classic pieces from the canon of Western art (his wilting take on Van Gogh's Sunflowers, for example), the message they place is usually designed to be cleverly at odds with the ad they've doctored.

Subvertisers' response to questions about criminal damage is also remarkably similar. "I see it as a right to reply," one subvertiser told *Venue* magazine. "Why should I passively receive these marketing messages but not have a right to respond? Advertising is eating into more and more of our public space, with adverts on the side of buildings, lasers in the sky, on pavements, advertising in schools and hospitals. We have no say in these billboards going up, and some are downright offensive.

"They put adverts for posh, expensive cars up in poor neighbourhoods where people have no chance of ever affording them. I also want people to see that there is resistance, that people are attempting to engage and have a dialogue instead of accepting being mindwashed. "

The subverts, like Banksy, have the benefit of universality. "You could hire gallery space and maybe 500 people would see your pictures. With this, thousands of car drivers and pedestrians see it each day." The two forms also share a reliance on humour. "The humorous ones get the best reaction, you get people honking and cheering as they drive by," the subvertiser told *Venue*.

Researching a piece about Bristol's subvertising culture, I asked the editors of south west anarchist magazine *Bristle* why people do this stuff. "A famous subvert from the Eighties comes to mind," came the reply. "The advert read 'If this car was a woman you'd pinch its

bottom' and the response was 'If this woman was a car she'd run you down'. It's a way of thinking that mocks authority, surveillance and consumerism." Sound familiar?

It all fits in, more generally, with a certain Bristol tradition of subversion, of people doing things their own way, refusing to be led by the prevailing fashions and truisms. *Bristle* itself, for example (in its own words "an anti/post-capitalist magazine which challenges the idea that capitalism is sustainable") has been spreading its leftfield gospel around the city since the mid Nineties and in 2005 published a collection of the region's finest subvertising images in *Political Street Expressions in Bristol and the South West*. It all chimes with the points Banksy makes in a short essay called *Brandalism* in *Cut It Out*, the third and final of his 'little black books'. He too clearly feels bombarded, harangued by advertising – or, as he calls, it 'chequebook vandalism':

"They [the advertisers] make flippant comments from buses that imply that you're not sexy enough and that all the fun is happening somewhere else. They are on TV making your girlfriend feel inadequate. They have access to the most sophisticated technology the world has ever seen and they bully you with it. They are The Advertisers and they are laughing at you."

Bristol graffiti artist Rowdy put it this way in 2003: "You've got billboards everywhere, people driving too fast with their mobile phone stuck to their ear. Then, when you get home, the television is either trying to sell you stuff or is just bombarding you with trivia or violence. I know graffiti is sometimes offensive too, but that's because it's trying to get a message across. For those of us who are never going to own some two hundred grand property, this is a way of saying that we own this environment too. Some people go out and start a fight in the Centre, this is at least a different way of venting frustration."

This one first appeared on a wall in Clifton before becoming a best-selling print at the old Greenleaf bookshop.

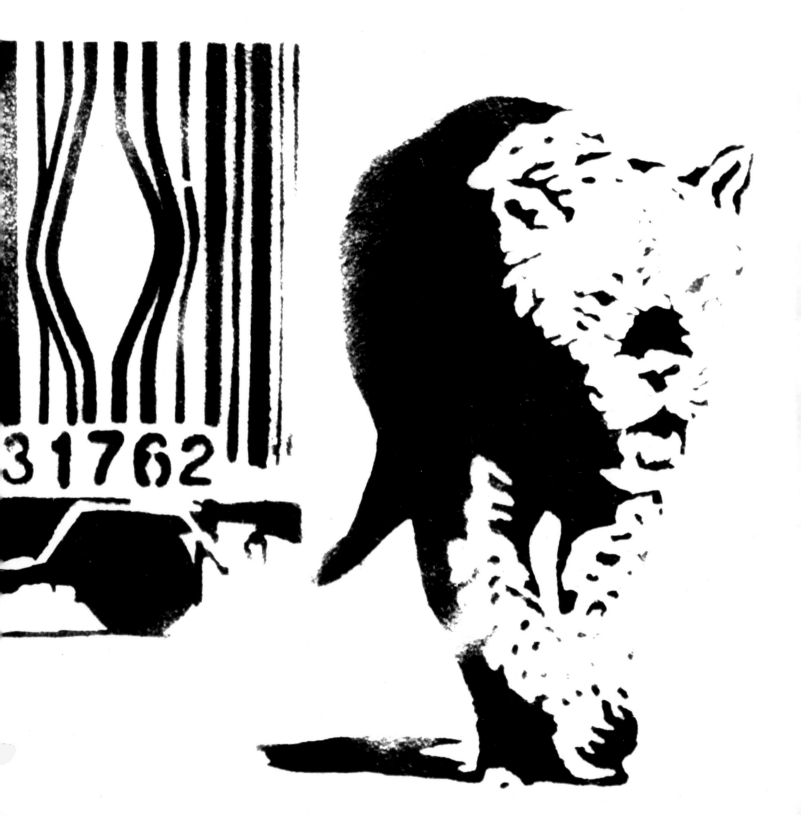

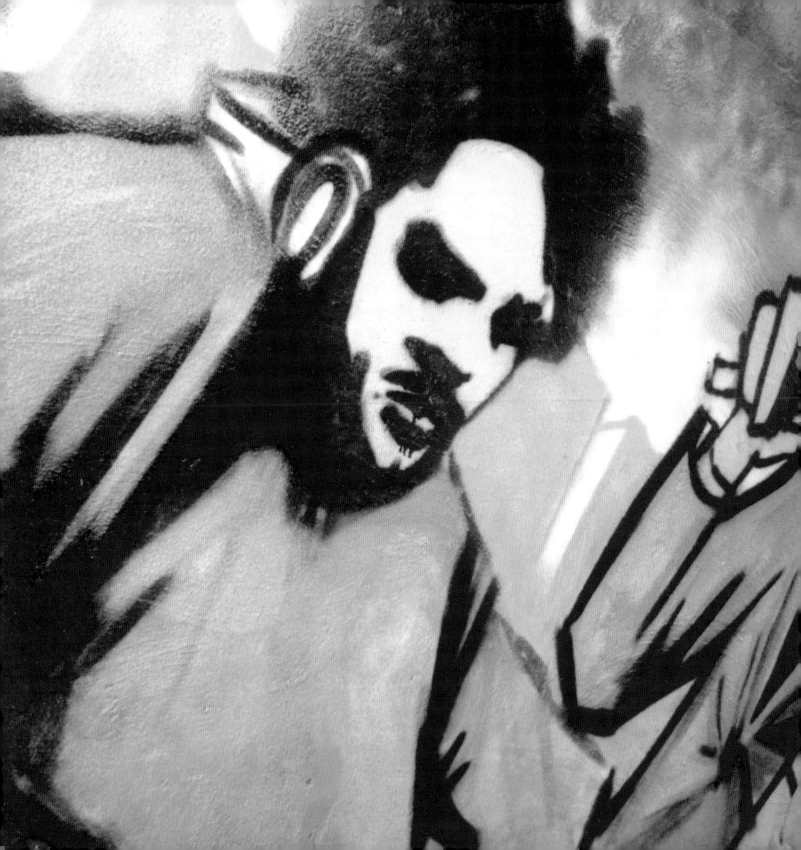

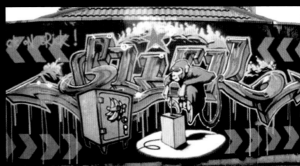

artist at work

"The craft is finding a decent drainpipe to get access to the site as much as it is in the art, and that's interesting to people… Van Gogh used short, stumpy brush strokes to convey his insanity – I use short, thin ledges above mainline train tracks."
Banksy quoted in *Bristol Evening Post,* **February 2004**

What can easily be forgotten, among all the froth about Banksy and the glamorous mystery surrounding him, is that the physical realities of doing what he does are almost always far from glamorous. Illegally painting on public spaces takes a hefty amount of resourcefulness, patience, physical fitness and stamina; it often involves heading out at the dead of night, shinnying up buildings or hanging from bridges, knowing exactly which CCTV cameras to dodge and police shift changes to profit from.

Some of Banksy's stunts have amazed and impressed because of the sheer bravery of the event. Walking into some of London and New York's most venerable cultural institutions and sticking his art up on the walls; working in secret, at night, often in dangerous environments. Check out the stories he tells, in *Wall and Piece*, of infiltrating Barcelona Royal Palace, surrounded by armed police. Or, more comically, of being stuck in the same city's Zoo, in the kangaroo enclosure, at midnight. Banksy associate Steve Symons recalls the stunt at London Zoo (where Banksy climbed into the penguin enclosure, daubing 'We're bored of fish' in seven-foot high letters) was one

This page:
Banksy's
first ever
stencil
appeared in
Windmill Hill
in the mid
Nineties.

That page:
Battling
surveillance
cameras in
Battersea
Road, Easton.

that gave its creator a few nightmares. "He was convinced that the graffiti he did in the penguin enclosure at London Zoo was the one that had wound the police up the most, and that they were really wanted to catch him for."

We know that on one night in Bristol, Banksy painted both Pero's Bridge and the Thekla floating nightclub, because he tells us about it in his book *Cut It Out:*

One night I painted the side of Bristol's new harbour bridge with a message about the slave trade which got painted over within six hours of daybreak. Afterwards, I made the slowest getaway in criminal history splashing through the darkness in a tiny rowing boat before stopping off to paint my name on the side of the Thekla.

"I heard he got chased by the harbour master," adds one Bristol graffer and friend of Banksy's.

Perhaps the most notable trip, even on Banksy's itinerary, was to paint the Palestine Segregation Wall in

2005. During the visit to Ramallah, Banksy reports some tense moments. His spokeswoman Jo Brooks said: "The Israeli security forces did shoot in the air threateningly and there were quite a few guns pointed at him."

Caution – artist at work

"It is incredibly exhilarating going out at night," says Bristol graffer Ghostboy. "It's the adrenaline buzz. And also the response you get: I can get my work up straight away and within days I'll be getting emails from people, the majority very positive.

"It's the cheekiness, getting away with it, living on your nerves. Sometimes you have to be really cheeky and do it in broad daylight. Rush hour is a good time to do it, because police responses are slower."

Banksy talks about his art in pragmatic, not highfalutin' language. He often cites the 'efficiency' of stencil art

EA RD. BS

as the thing that most excites him, as he told *Guardian* interviewer Simon Hattenstone in 2003:

I ask him if you need to be nimble to be a good graffiti artist. "Yeah, it's all part of the job description. Any idiot can get caught. The art to it is not getting picked up for it, and that's the biggest buzz at the end of the day because you could stick all my shit in Tate Modern and have an opening with Tony Blair and Kate Moss on roller blades handing out vol-au-vents and it wouldn't be as exciting as it is when you go out and you paint something big where you shouldn't do. The feeling you get when you sit at home on the sofa at the end of that, having a fag and thinking, there's no way they're going to rumble me, it's amazing... better than sex, better than drugs, the buzz."

How not to get caught

From the early Eighties, Bristol's seminal street artist Nick Walker was heading out to create his urban canvases at 4am to coincide with police shift changes: "You're always nervous about being caught, but, after you've had a few pints you get Dutch courage, and you feel like a superhero," he told *Venue* magazine in March 2006. "We're brought up in a society where everywhere you look, there's some billboard telling you to buy this or vote for that. If their views are up there in massive letters, why shouldn't yours be? So you find that wall you've always wanted to paint, and just go and do it. Daytime was best: no-one expects you to do it then, and no-one does anything about it either: they're too wrapped up in their own little worlds."

On his website, Banksy once told the story of how he was standing in a shallow switched-off fountain in the small hours, spraying a piece, when his low-slung jeans (no belt, in the hip hop style) began creeping down his legs. Needing one hand to spray and the other to hold the stencil in place, he couldn't pull his jeans up, and needed to finish the piece fast to avoid arrest. He finished it "standing in a kind of Led Zeppelin rock pose to keep my sodden, beltless jeans from falling into the water. There was no way I was going to let go of the stencil before it was done, so eventually I lost the trousers all together."

His tip? "Fuck hip hop – wear a belt."

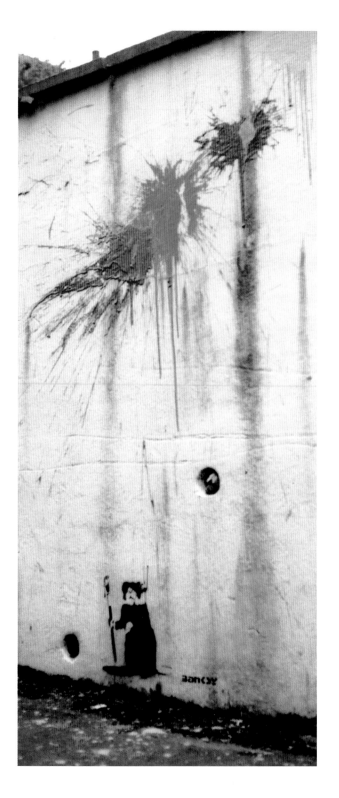

Banksy and stencils

From where we see it now, Banksy's career seems to have taken off from the moment he ditched freehand graffiti and picked up a stencil. But, as this close friend and collaborator tells us, Banksy's use of stencils goes back a lot further.

"The very first time I met him, probably 1992-94 time, he was down Bedminster skate park hanging around as we were painting, and he'd been doing these 'ant' stencils everywhere. I had seen them before and wondered what they were. We got chatting, and started to hook up every now and then. When we first went to his house/studio, what struck me straight away was that it was a hive of creativity. His conversation was full of plans for different projects and ideas for putting up work around the city.

"The first time we painted pieces together, he mixed freehand graff with stencils. I think it was just easier to put work out on the streets with stencils, rather than freehand stuff... a more instant, prominent hit.

"You have to realise that stencilling had been around already, not particularly in Bristol (although Nick Walker was already using stencils in his work), but definitely in Paris and a bit in London. Banksy was just very prolific, so before long his stencils started to appear all around, and people started making out it was a new thing."

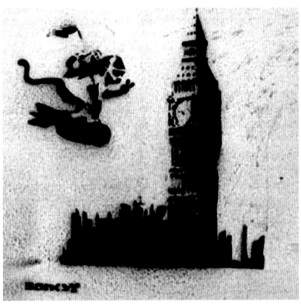

Animals feature strongly in Banksy's work, particularly rats. Rat is an anagram of art...

Ghostboy on stencils

"I did a bit of freehand stuff when I was about 18 for a year or two, but back then I think most graffiti only appealed to other graffers. I started placing sculptural stuff on the streets (I still do) as well as stencils, but the stencils just seemed to resonate with other people more (maybe it's because they are less cartoon-like). I also think that less is more, and the punchiness of stencils works better if you are trying to get something across. The hard work goes on in the studio and the convenience of banging a stencil up means you can get them in more appropriate places.

"Banksy's career did take off when he went from freehand to stencil. That was partly because it was still relatively unusual to see street stencils in this country when he started doing them, so they had the curiosity value. Also, you can put up 20-30 stencils in the time that it takes to do a decent freehand piece, which means you can get them seen by more people. The more people see your work, the better. Political activists have used stencils for years in other countries, and so have the army (to label their ammunition crates and vehicles), so the form was begging to be used – and subverted – by artists."

Bristol Zoo

"I remember the night Banksy did Bristol Zoo," recalls photographer and Banksy acquaintance Matthew Smith. "The evening before, I was at the Black Swan in Easton, and he was there too, along with a bunch of mutual friends. At 4am, I got this call from him, saying he was down at the zoo and would I come and take some pictures the next morning because he was about to do the seal sanctuary and a couple of other places.

"The next morning, around 9.30, having been up all night and quite the worse for wear, I got to the zoo. I found

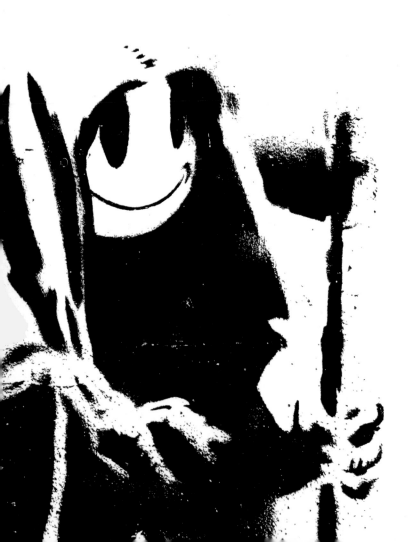

the seal sanctuary and shot a few pictures of Banksy's work. It was a big 'We demand more fish now!' slogan with an A for anarchy, on the wall at the back of the sanctuary.

"I was snapping away when I was rudely interrupted by the arrival of a group of about ten police, who must have been alerted by the Zoo. I just kept my eye on my camera and pretended to be photographing the seals."

Banksy elaborated on his philosophy in an interview with *Swindle* magazine: "Ultimately, I just want to make the right piece at the right time in the right place. Anything that stands in the way of achieving that piece is the enemy, whether it's your mum, the cops, someone telling you that you sold out, or someone saying, 'Let's just stay in tonight and get pizza'."

On several occasions, Banksy has used plain cheek and ingenuity to do what he does. This graffer and close friend of Banksy's spilled the beans on how Banksy's iconic window-hanger mural on Frogmore Street in central Bristol was achieved.

"Banksy organised for some scaffolding to be put up on the building, with full covering over it, like when they're taking off render and the cover keeps debris from flying everywhere. On a Sunday, once the scaffolding and covering was up, the piece was painted pretty much under cover from anyone on the street. When he'd finished, he just had to phone the scaffold company to take it down... job done!

"He will have taken a lot of care designing that one, studying the surroundings to make sure it fits, even taking measurements. Take a close look and you'll see that the window has been drawn to exactly replicate those just around the corner of the building; and its base is on exactly the same level as the other windows. As for the naked man hanging down, you can see his muscles stretching and straining as he hangs. You can feel the gravity pulling him downward. That's why that piece works so well and is so popular – for a few seconds it will deceive any onlooker."

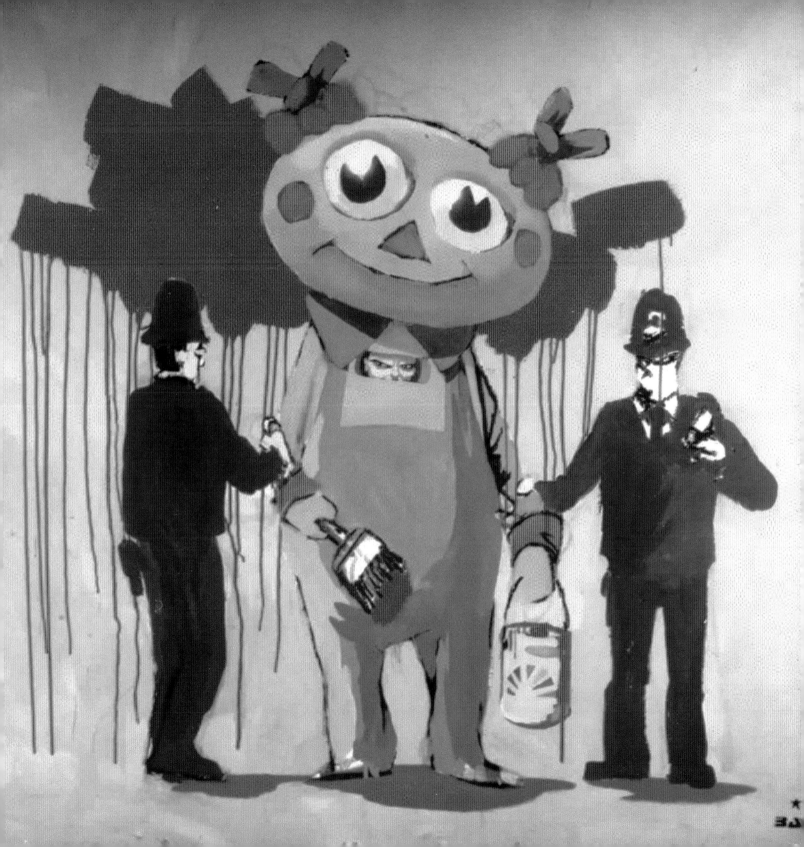

anonymity rules

"I have no interest in ever coming out. I figure there are enough self-opinionated assholes trying to get their ugly little faces in front of you as it is."

Banksy in *Swindle* magazine, Issue 08

t's quite a thing to maintain anonymity – especially when you're having the impact Banksy is. In many ways Banksy s one of the most recognisable brands on the planet, but ho one outside his social circle knows what he's called, or what he looks like. How does he manage this? Part of his continued anonymity comes down to the amount of oyalty he commands from his friends – so much so that people will steadfastly refuse to give away clues about him. His mix of extremely prominent, attention-grabbing stunts and near-complete personal mystery is unique, an

impressive kind of reverse exhibitionism.

Why has he maintained this anonymity? To elude the police, of course – but is it not also an attempt to construct a powerful aura, a cult of Banksy? He might well scoff at that notion, but it has undeniably been the main consequence of his anonymity. Would we value him as much if we knew his identity? The fact is that the myths and the Banksy 'brand' are more interesting than a few bald facts about him.

"The anonymity is a very useful device, quite apart from the sheer necessity of not getting caught: because it gives Banksy's art a longer shelf life," says Martin Roberts (not his real name), a friend from the free party scene. "It's much more interesting to be able to look at his art work without getting too involved in his personality, without trying to project his personality on it. He's famous but somehow non-famous, because no one knows who he is. And that's the best situation to be in: he's made a lot of money doing

Banksy originally started painting graffiti with the DBS crew from east Bristol. DBS included Kato, Lokea, Juster, Soker and Tes – most of whom are still painting in Bristol today.

something he loves, and yet still has complete control over his image – he isn't public property at all. Also, people like to build people up and then knock them down – as we've done with Beckham, Barrymore, Britney, whoever. But it's quite hard to knock someone down without even knowing who they are.

"When Banksy makes statements, it's more potent because it's just the statement that we hear – it doesn't get mixed up in our perception of who he is. Contrast that with, for example, David Hockney fulminating about his right to smoke in public, or, worse, Madonna or David Beckham getting into the Kabbalah. It's difficult to take them seriously, to listen purely to what they have to say on the subject, because you're basically just thinking, 'Yeah, come off it! This is David Hockney or David Beckham talking here!' You can't divorce what they say from what you know about them. Banksy's mystery makes his views somehow more authentic. Part of the appeal is that we don't know who he is, so we can engage with his art without having that dulled by our knowledge of him, or by a celebrity obsession with him."

Banksy seems to agree with this view himself. As he notes in his book *Existencilism*:

You find that people who know you rarely listen to a word you say, even though they'll happily take as gospel the word of a man they've never met if it's on a record or in a book. If you want to say something and have people listen then you have to wear a mask. If you want to be honest then you have to live a lie.

Being yourself is overrated

In the words of one Banksy acquaintance: "Banksy's a clever guy, but keeping your mouth shut can make you seem much more intelligent than you really are."

The anonymity, though, seems to be purely pragmatic, with the mystique being a (fortunate?) by-product. "You've got to have a degree of anonymity as a graffiti artist," says Ghostboy. "You don't want to go giving out your name, address and telephone number if you're committing crimes. It's risky work. How can you concentrate on the work if you're answering the door to the police? But yes, it does help keep the intrigue alive.

You have this bizarre ongoing 'who is he?', intrigue, which is also propped up by the media, because they get so many column inches from it. Once that anonymity ends, it's kind of game over as far as they're concerned."

Banksy, again: "Being yourself is overrated anyway. It doesn't help. People say 'I'm just being myself' as if that's some kind of fucking achievement. That's not an achievement, that's not honesty, it's lack of imagination and cowardice."

Steve Symons met the artist regularly when he shared a Stokes Croft office with Banksy's former manager. "I once got a call from a friend on the *Observer* saying he was going to email me a picture of Banksy, and would I say if it was him or not. I was like, 'well, no, because he wants to retain his anonymity'. He sent me the picture anyway, and it was a picture that's been used in the media quite a few times, and claimed to be 'Banksy'. So I said, 'well, I don't know if you'll believe me after all I've said, but that's not him'. My friend was like, 'brilliant, that's exactly what we thought. The *Daily Mail* printed this a couple of weeks ago, so we've got one over on them'. And then I noticed, a few weeks later, the photo appeared, captioned as Banksy, in the *Guardian*. It just seems to go around and around. So he does very well at maintaining his anonymity."

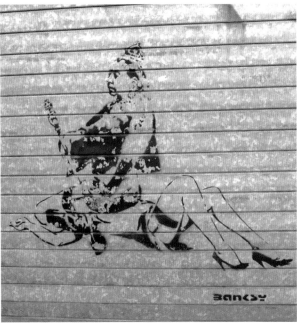

The Queen Victoria pieces were removed pretty quickly. This one survived longest because it was on the shutter of a shop that stayed open 'till 9pm.

Banksy and me: MsBehaviour

Helen Baxter, aka MsBehaviour, lived in Bristol in the 1990s, when she was Helen Rees. She is now a DJ in New Zealand

"Banksy's art was part of my urban landscape. You never knew what might lie around the next corner. He made my walk to work a little more bearable. His ode to Free Party Abi, teddy bears in the Mild Mild West, monkeys, rats, clowns. Disturbing, political, or laugh-out-loud.

"We met a few times at The Farm (a pub in St Werburgh's) over a pint or three, and I saw him in action once at Glastonbury. He was intelligent, softly spoken, and always taking the piss out of everything and everyone – including himself. He loved doing pieces for the kids, and hated any celebrity shit. I live in New Zealand now but felt a glow of Bristol pride when I saw his art on walls in Palestine. I laughed my ass off when I saw his pink elephant in LA. He still makes me smile. He still makes me think. Is Banksy for real? Definitely."

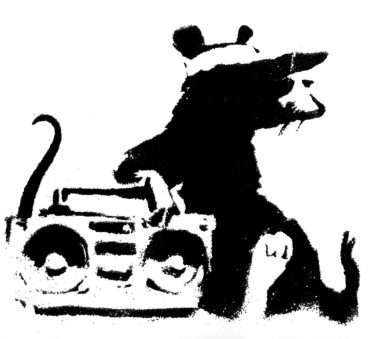

This page: Stickers handed out at anti-war demos in Bristol and London.

That page: A 1997 stencil outside public toilets in Weston.

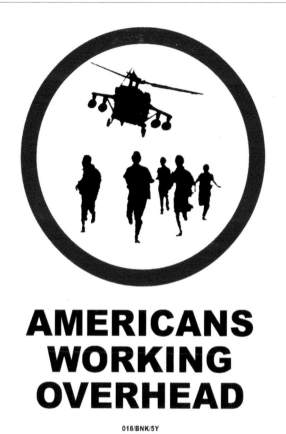

AMERICANS WORKING OVERHEAD

018/BNK/5Y

John Mitchell

John Mitchell was *Venue* editor from 1998-99, during which time he interviewed Banksy and put him on the cover of the magazine

"I got to know Banksy through Inkie, who I knew well at the time, and what I liked about both of their work was that they were taking spray art out of its self-ordained Wildstyle* ghetto and into all sorts of new areas. I worked with them in 1998, when they decorated the Glastonbury Dance Tent together.

"At the time, Banksy and Inkie were doing a huge range of styles – everything from gothic lettering to big clown figures. Then Banksy moved away to concentrate much more on the stencilling. He wasn't a national name in those days – he was quite well-known around Bristol and he was quite enjoying his anonymous notoriety, but it was a long time before he sprang onto the national stage. He was enjoying the attention he got from women, and doing his own particular innovative flavour of art.

"*Wild Style* was a phenomenally influential film on the original Bristol pioneers, and it continues to exert a great (I would argue an undue) influence over artists. Banksy's art was just so much more intelligent than the fairly repetitive, tag-based stuff you were seeing around town until then. It was taking graffiti into a whole new arena where no one had gone before. It was more politically engaged, funnier, more provocative. I remember there was another graffiti crew in Bristol at the time who had completely the opposite perspective: for them, *Wild Style* was the beginning and the end. Their mission was simply to repeat what was all around the New York subways, all around Bristol. Inkie and Banksy, who were kind of a duo in those days, took a far more individualistic outlook.

"He struck me as being a thoroughly nice guy – very thoughtful, not particularly on a mission to change the world or raise political awareness. He just wanted to do his art and produce stuff that made people think a little. His work was still developing at the time – his recent stuff is much more technically and creatively advanced. He was getting the stencil thing going, mainly because it allowed him to operate faster.

"He came into the *Venue* offices before an interview. He didn't seem that bothered about being recognised – but this was before things took off for him. I never thought that Banksy's anonymity was a pretentious thing, it was for self-protection. If you're spraying all over public property, you need to be anonymous. But I was a bit concerned when my 12-year-old daughter developed a crush on him, and I asked why and she said, 'he's sooo mysterious'."

** Wildstyle is a highly expressive, intricate freehand graffiti style, which uses interwoven and overlapping letters and shapes. It had its roots in 1970s New York City and has been hugely popular and influential ever since. Wild Style is also the name of a seminal 1982 film about old-school hip hop and graffiti culture.*

In the picture

Bristol graphic designer Azlan took a rare official shot of Banksy

"Like most graffiti artists, Banksy preferred to remain anonymous, and felt cagey revealing his identity to the press for fear of prosecution by the police. I remember taking a portrait photograph of him for an early artist feature in a drum 'n' bass magazine in 1997. We decided to have him move in the shot to blur his identity. As far as I know, it was the first and only official image taken of him. In later press photographs, his old housemate would pose for the cameras wearing a mask.

"The whole thing about his anonymity was really created by the media for the media. They seemed to latch onto a shred of information they thought unusual and slowly re-invented Banksy as a mythical artist, not a person. Now it seems that the more mythical his identity, the more notorious his artwork/stunts have become."

Lizard kings

Petunia Begent went to the Lizard Festival, during the total solar eclipse of 1999, with Banksy

"I remember we were all sitting around, the three of us – Banksy, Sally, my friend who knew Banksy well, and me. I didn't know him that well. We'd heard about this festival down on The Lizard in Cornwall to coincide with the solar eclipse, and we all really wanted to go, but we needed to do something to get some money together while we were there. We'd all been to a few festivals that summer and were pretty skint.

"We decided to do a stall at the festival. I suggested selling these Chinese fortune sticks, and Sally wanted to do a jewellery stand, but Banksy was up for something a bit different. He said, 'let's do a coconut shy!' I asked him how he planned to do that, and within five minutes he'd sketched out exactly how the stall would look. He was like that – completely focussed and sure of what he wanted

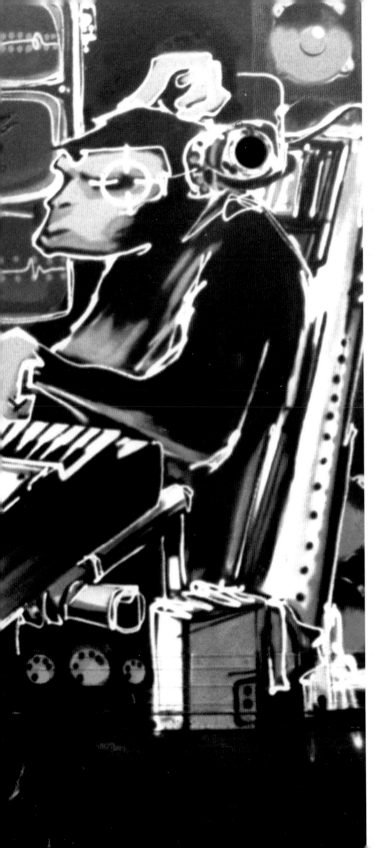

to do. Basically, we were going to have a coconut shy and lots of rum and pineapple juice and serve pina coladas.

"He knew this guy who could get us a few sacks of coconuts, and we got hold of very strong rum and served pina coladas in the coconuts. We just used scaffolding poles with nuts on the top for the shies, and tennis balls and netting. Banksy painted a 'Coconut Shy' sign as well. We did the stall only at night, so that everyone was so trashed they couldn't see straight. I remember Banksy rushing behind the stall to pick up the tennis balls all the time. He also painted one whole side of this articulated lorry near the stall, with all these monkeys on DJ decks.

"The festival was a bit anarchic in the end, because the security guards all left because they weren't being paid enough. It was a bit of a free-for-all – the best festival I've ever been to. I also remember Howard Marks came over and tried our pina coladas. He liked them so much, he said he'd be endorsing them all through the festival.

"I was just amazed that Banksy was so up for anything, any way to make a bit of money. He just had this incredible energy and made you feel anything was possible."

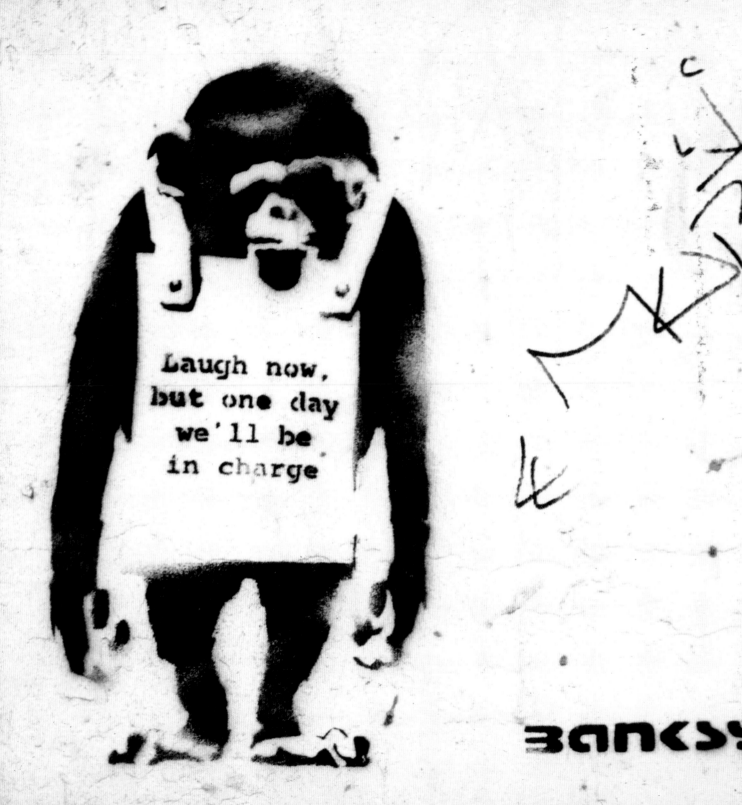

making art work

So, where can we place Banksy in the art pantheon – and does it matter? If one of art's functions is to provoke reactions, to make you think, turn accepted notions on their head, and to do all this in as sharp and accessible way as possible, then you could easily argue for Banksy's place near the top of the tree.

Banksy seems unconcerned about how the art world views him. "The art world is the biggest joke going," he said in *Swindle* magazine. "It's a rest home for the over privileged, the pretentious, and the weak. And modern art is a disgrace – never have so many people used so much stuff and taken so long to say so little. Still, the plus side is it's probably the easiest business in the world to walk into with no talent and make a few bucks."

In October 2005, speaking to *The Times* about his *Crude Oils* exhibition which featured 200 live rats roaming the gallery space, he justified the rodents' inclusion by claiming he would rather cross town to see 200 rats, than an exhibition of paintings.

Why is he so unimpressed with the art establishment? Largely, it seems, because he sees it as a self-sustaining, self-congratulating little coterie. He observed in *Wired* magazine in August 2005 that: "Art's the last of the great cartels. A handful of people make it, a handful buy it, and a handful show it. But the millions of people who go look at it don't have a say. I don't do proper gallery shows. I have a much more direct communication with the public."

He expands on the theme of democracy through art in his book *Wall and Piece*:

Art is not like any other culture because its success is not made by its audience. (…) The Art we look at is made by only a select few. A small group create, promote, purchase, exhibit and decide the success of art. Only a few hundred people in the world have any real say. When you go to an art gallery you are simply a tourist looking at the trophy cabinet of a few millionaires.

Just after his Bombing Middle England piece sold at Sotheby's for £102,000, an image appeared featuring an

auctioneer holding court before a group of enthralled art buyers. The painting they were bidding on was a plain white canvas inscribed with the words 'I Can't Believe You Morons Actually Buy This Shit'.

It's the street, not the gallery, that resonates for Banksy – and for many others. "Every other type of art compared to graffiti is a step down," he said in *Swindle*. "Other art has less to offer people, it means less, and it's weaker. I make normal paintings if I have ideas that are too complex or too offensive to go out on the street, but if I ever stopped being a graffiti writer I would be gutted."

After sneaking his Warhol-esque painting of Tesco Value tomato soup cans into New York's Museum of Modern Art, Banksy recalls: "I took five minutes to see what happened next. A sea of people walked up, stared and moved on looking confused and slightly cheated. I felt like a true modern artist."

Bristol art collector Martin Roberts has known Banksy since the free party days of the Nineties. He admires the way in which the artist and his agent, fellow Bristolian Steve Lazarides, play the art world through the LazInc website and the Lazarides gallery in Greek Street, Soho: "Banksy and Steve are like the Sex Pistols of the art world – they are not playing the art game, or the gallery system. They don't need Charles Saatchi, they're controlling the process in their own way."

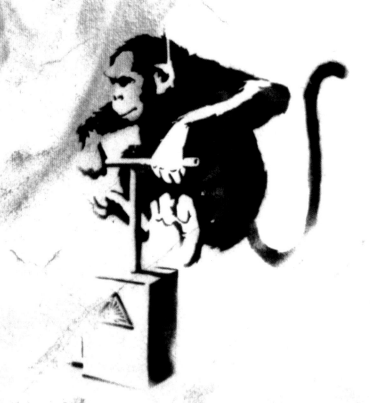

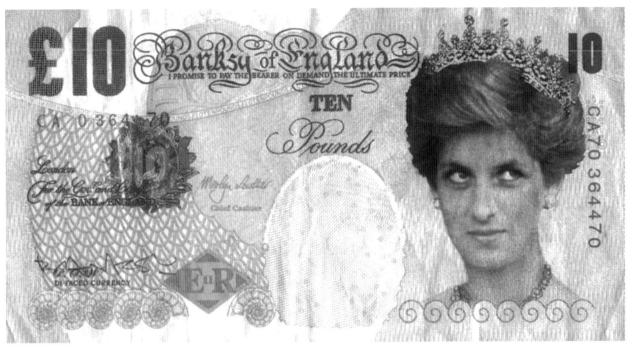

In his book *Banging Your Head Against A Brick Wall*, Banksy observes that 'The quickest way to the top of your business is to turn it upside down': and that is, you can argue, exactly what he's done. "He could easily have sold out, and made a packet, doing interviews and commercial work," Roberts adds. "But he hasn't. He's carrying on purely for the love of his art, and that's quite a rarity."

The perfect example of turning the art world on its head, of course, was Banksy's infiltrations into various New York and London galleries and museums. Between March and May 2005, he snuck his way into four of New York's elite cultural institutions (the Metropolitan Museum of Art, the Museum of Modern Art, the American Museum of Natural History, and the Brooklyn Museum), plus London's British Museum, and stuck his own alternative artworks on the walls – an eighteenth-century debutante clad in a gasmask; an admiral clutching a spraycan in front of anti-war graffiti. Before that, in October 2003, he had made his way into Tate Britain and glued a painting – a classic eighteenth-century pastoral scene, altered to include police incident tape – to the wall. Banksy told the graffiti website www.woostercollective.com: "They're good enough to be in there, so I don't see why I should wait."

For sheer chutzpah, as well as the point they were making and the place they were making it, these museum 'stunts' rank as some of Banksy's finest. Yet, for all his shoulder-shrugging humour, his presence in these hallowed spaces meant something to him. In a telephone interview with the *Sunday Times*, he admitted to being flattered that the galleries he has infiltrated have left his pieces hanging. "I'm the only one from my generation there," he said. "In some of these places you are meant to be dead 200 years first."

He's showing us that art doesn't have to be produced by a self-perpetuating coterie of 'in' artists, nor consumed by someone with an art degree and a few lofty phrases. Some of the things he has done – those museum incursions but also some of his street interventions, like the wave of traffic cones apparently sinking into quicksand-like-tar on a London street – transform your whole idea of how public spaces look, what is normal reality, what assumptions we make about what we see around us.

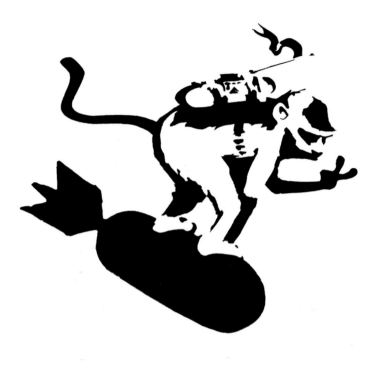

Anyone can have a go

"It's making art as affordable as possible to as many as possible," says Roberts. "The POW website also supports emerging artists, because the presence of Banksy's work on the site attracts huge traffic – visitors who then start browsing and buying work by other artists in the store."

And of course, the very medium that Banksy has chosen also means that he doesn't have to play by the same rules as the art establishment. Stencil art is by its nature relatively fast and easy to produce, meaning that he's been able both to produce and sell his pieces cheaply, and to encourage others to do the same. It's, in intention at least, the very opposite of a rigid art hierarchy. For his first London exhibition in 2001, Banksy simply whitewashed a tunnel at Rivington Street, Shoreditch, spraying 12 of his pieces (within 'frames') directly onto the white walls. Art surely doesn't come any faster or more accessible than that.

He made perhaps the ultimate statement of this DIY art when, in the summer of 2002, he allowed *Bizarre* magazine to give away a free stencil of one of his designs, featuring a rat smoking a cigarette and holding a shovel. 'This isn't just me', was the obvious message behind this unusual freebie. 'Anyone can have a go.' His books also feature advice for the would-be stenciller.

"He's changing the way we relate to art," says Roberts. "He's making it more accessible, no longer a rich man's painting club. It's pretty hard getting people hooked into art if you say, 'right, this is a Rembrandt – now you have a go!' That's not inspiring, because it doesn't feel achievable. Banksy, on the other hand, is quite explicit about how he produces his pieces and tells others how to make their own."

The way he goes about selling his art is also, largely, democratic and open to all. Pictures on Walls is an online prints sales service featuring work by Banksy and other talented, graff-influenced artists. Banksy prints will go on sale on the website (www.picturesonwalls.com) for under £500 – not bargain-basement prices, sure, but still relatively affordable in the modern art world, particularly when you consider the top prices his work is now fetching. There seems to be a philosophy of generosity, both of nurturing talented artists and of making their work affordable to many more than just those with a five-figure bank balance. "When we sell prints at below their true market value, that is done at the artist's request, not because we're stupid," says the POW website.

It also reads: "Every POW edition print so far has sold out (eventually). They are always on eBay for more money. We genuinely set out to make art available to more than just tossers and gangsters." We've heard a rumour (which neither Banksy nor agent Steve Lazarides would confirm nor deny) that Pictures on Walls tries to discourage 'flipping' – buying artwork at cheap prices on the site and then flogging it on at huge profit on Amazon or eBay.

Who's laughing now?

"The art world is the biggest joke going," says Banksy. So what does the joke make of him? Alan Bamberger is a US-based art consultant and author

What's Banksy's future on the global art market?
I think the Banksy bubble will burst. Basically, he's unproven. What determines whether an artist ultimately goes on to sell for huge amounts of money, is whether that artist is able to produce gratifying work consistently over a long time, of equal or better quality than the art that's been produced up until then. And, with Banksy, the jury's still out on that. At the very least, you have to leave it a couple of decades: that's when the people who really count – the curators, the scholars, the people who actually have standing in the art business – take a look at this work and say, 'OK, is this for real? Or was it just a fad, a flash in the pan?' While it's happening, you don't really know.

What do you think of his stuff?
He has a very engaging take on urban art. His work actually makes you think. You're not just looking at a typical piece of graffiti: there's a story there, there's something happening, something to think about, a message. Even if the message is no message, there's something else happening, that extra intangibility that

The rat is a recurring image. At his Crude Oils show Banksy released 200 into the gallery.

works so nicely. Plus, he's done some things to help himself, like placing these bogus pictures in museums – he's very good at garnering publicity for himself.

How might Banksy's legacy look?

Too many people confuse artists with athletes, like you draft them out of college and they're in their twenties and brilliant at some particular sport, but by the time they're 30 they're basically done. The opposite holds for an artist: they can come onto the scene and be brilliant and fresh, but will they still hold that attraction years down the road? Project yourself forward a few years, and imagine the hundredth time you see another Banksy stunt: will it be, 'OK, it's Banksy again, whatever', or is it going to fascinate you again and again? There's a crucial transition from fashionable to true greatness. But from where I see it now, he could definitely be looked on as someone who changed the art scene and made an impact.

But the current boom won't be sustained?

It's an aberration, and generally these things work themselves out. My guess is that the people paying these ridiculous amounts are not professional, experienced art collectors. I would guess that there's a money angle, they can see that his stuff is going up and up at the moment, but I don't think we have a really dedicated, moneyed fanbase to sustain this level of price increase. It makes no

sense: how can something be worth $100,000 today and $200,000 in a month? How can that be?

Has he climbed too far too quickly?

He's under heavy, heavy pressure to perform. Is he able to take it, is he able to continue to produce, or is he just going to disappear? That's another unresolved issue. With art, it's all about the long-term.

Will Banksy survive in the long term?

He has all the raw ingredients to go on to be an important and influential artist: but we don't really know yet, and it's a very long game. At his L.A. show in 2006, Angelina Jolie spent some ridiculous amount of money on some of his pieces, and, of course, all that celebrity gossip gets people excited. But Angelina Jolie is not known as an art collector, she just has a lot of money. She doesn't carry any weight in the art world. It's like, OK, they're fetching these prices, but who's doing the buying here? Do these people know what they're doing, are they influential art market players?

So, what's it worth?

Ralph Taylor from Sotheby's Contemporary Art department on Banksy's extraordinary journey

"Part of Banksy's impact has been because he has come from the whole urban/street art context, which had its roots in 1980s graffiti and hip hop culture. That has meant that he has appealed to a whole new generation who previously weren't buying art. His art is also accessible to all – you don't need to go to galleries or have the benefit of a rarefied artistic education to enjoy it – they are up on the streets for all to see. And perhaps most important of all is his gallows humour – his work is anti-establishment, but it uses laughter to get its point across. It is also, visually, very easy to understand – which means that it both catches the eye of the passer-by, and is also relevant across social and cultural boundaries. Grannies, kids, people from outside the UK: everyone 'gets' Banksy's work. But he's seen as dangerous, because of the illegal nature of his street work and because of his anti-establishment messages.

That danger adds to the excitement around him. People who are part of the establishment are buying strongly anti-establishment pieces, and I think there's a frisson of irony, of danger for them in that. It's a strange relationship, but one I think both sides get a lot out of.

"His impact has been phenomenal. To have reached his level of interest so quickly is extraordinary. It helps that he is part of a group of artists – Antony Micallef, Adam Neate, Jamie Hewlett, Paul Insect etc – who often collaborate and feed interest into each other's work, which thus creates its own market.

"Banksy's proven to be extremely robust. At the beginning of 2007, there was a phenomenal demand for Banksy pieces, and people were paying incredible prices. It was a case of 'I want a Banksy, no matter what.' There was also a large supply available, because a lot of people bought Banksy pieces for, say, £200 in Bristol back in 2000. Being able to sell that for perhaps 100 times the original price was extremely enticing – show me a hedge fund manager who would ignore the potential of a 10,000 per cent return over just a few years, let alone regular guys from Bristol who bought because the message resonated with them! This is another secret to Banksy's commercial success; as art is developed as an alternative asset class, investors are always on the look out for the next big thing, which can explain some of the steepness of his curve.

Post-Berlin Wall zeitgeist. Eh?

"I think interest in his 'edition' canvases* and some of the more obscure images might plateau. But if we were to see, say, a really strong architectural piece (such as a stencil on a wall or piece of iron where the street context is still linked to the work), the sky's the limit. That's where the interest will come from, when he's creating something truly original. I also think that he is extremely significant art-historically – the Princess Diana £10 notes that he placed all over London are incredibly powerful and the murals on the Palestinian wall capture both a post-Berlin Wall zeitgeist as well as representing an act – he is not just saying something serious, by going on location he is doing it too. Damien Hirst's show *MurderMe* in 2006, which was the first public exhibition of (a small part of) Hirst's

own collection, featured three or four Banksys. The cover for the exhibition catalogue, a tattoo design, was also by Banksy. So Banksy has been endorsed by the pre-eminent artist of our generation. If Damien Hirst, no less, thinks Banksy is the real deal, then you can understand new collectors saying, 'who are we to disagree?' Personally, I think it's important he continues to do his stunts and get his messages out there in the imaginative, absurd, unsettling ways he always has done. It's crucial that he maintains the integrity of doing things on the street, showing that it is still all about the message."

*An 'edition' canvas is where an artist uses the same stencil on a series of 5-15 identical canvases; each piece is the same but the artist's hand is still evident in each through the spray can – which is not the case with prints.

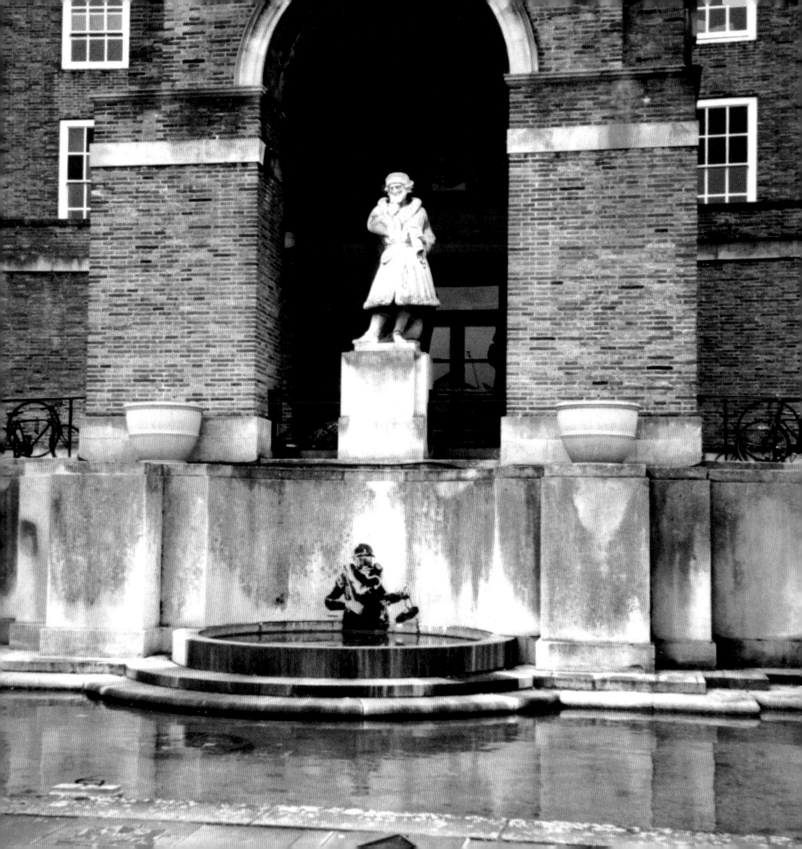

home sweet home

One of the most fascinating parts of the Banksy story is how, in his native city, he's helped drive a massive public debate about graffiti – whether it's ever art or always just criminal damage, where we want to see it, and by whom. Of course, he hasn't been the only Bristol artist to change public perception. Graffiti writers such as FLX and Paris have also worked hard to change the public view of graffiti, encouraging local kids to get away from tagging and experiment with more inventive graffiti styles. But the debates around Banksy's Bristol pieces have been the most prominent.

Banksy and the City Council

August 1998

Inkie and Banksy collaborate at *Walls on Fire*, a weekend-long festival of street art with the blessing of the City Council. Top graffiti writers from across the UK paint a 400m stretch of hoardings running around the Bristol 2000 site – the future At-Bristol.

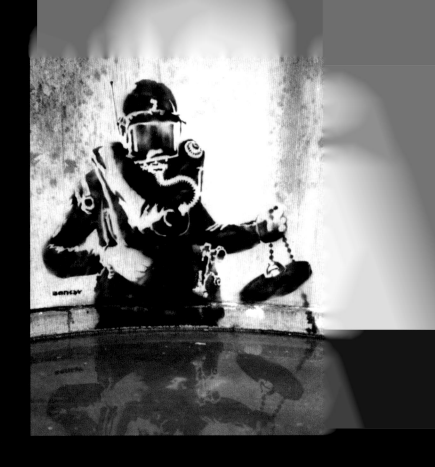

June/July 2006

The debate over Banksy's Frogmore Street piece begins.

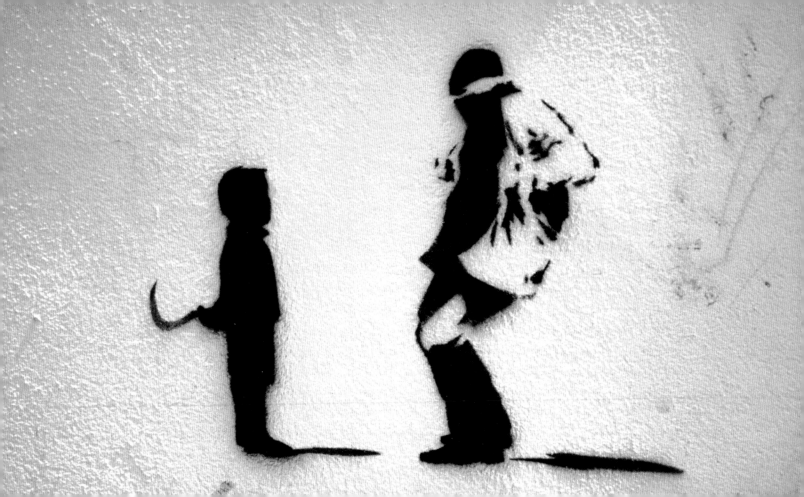

Banksy tales

Gez Smith worked for Bristol City Council and helped to push for a public debate about Banksy's Frogmore Street piece

"The Council were washing off stuff more indiscriminately a few years ago. Now they pause for reflection more often, which is good. They have been a bit contradictory about what is and what isn't good art. I actually think Spud Murphy had a point – what actually is graffiti and what isn't? I'd like it if the Council simply said, 'we'll take down graffiti if it's crap, but if it's a nice, well-thought out piece, and adds something to the area, then we'll leave it.'

"I love what PRSC, for example, are doing [the People's Republic of Stokes Croft, an organisation of artists and residents who, in 2007, started to decorate the Stokes Croft area of central Bristol with impromptu street art]. Because ultimately people, not the Council, own the streets.

"On the other hand, although it's a real shame that loads of Banksys have gone, that's what it is: it's street art, it's ephemeral. You wouldn't expect to be able to go to an original Pink Floyd concert any more, so why should you expect to see an original Banksy? Street art, like music, moves on..."

A railway cleaner's guide to art

In March 2007, workers employed by Network Rail to erase graffiti were given art lessons, to ensure that they didn't inadvertently erase any more of Banksy's work. The graffiti-cleaning teams were shown examples of Banksy's work after staff had painted over one of his murals (a monkey detonating a bunch of bananas) in Leake Street next to Waterloo station.

A Network Rail spokesman said: "We take a very tough line on graffiti, which is an anti-social crime affecting both passengers and staff, and costs the railway industry millions of pounds every year. Dealing with graffiti also diverts valuable resources away from improving the railway.

"However, given the possible value of some of Banksy's work, we have circulated examples to employees and contractors involved in cleaning up our property. If they see something they think could be by Banksy, then they are to notify their manager, who will come along to inspect. If feasible, we will consider the option of removing the graffiti and look into whether it can be auctioned for charity or donated to a local museum, gallery or other organisation."

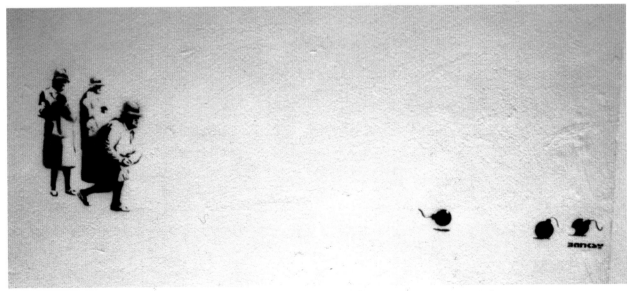

These two were in Montpelier but have long since gone.

The lost Banksys

Countless Banksy pieces have been lost – erased by zealous council graffiti removal teams, or hacked away by opportunistic street-art thieves. Here are a few examples:

2006

Stencil of a rat bouncing a beach ball under a 'No Ball Games' sign is cut from a wall in Paddington, west London and auctioned on eBay for £20,000.

April 2007

A group of transport workers paint over Banksy's Pulp Fiction-inspired mural in Old Street, Shoreditch, London. Experts value the piece at £250,000. "You wouldn't paint over a Van Gogh, nor should you paint over a Banksy," comments an alleged friend of the artist.

May 2007

A failed attempt to chisel a 'flying rats' mural from a wall in Whitechapel, east London. The piece is ruined.

Former *Venue* magazine publisher Dougal Templeton's lost Banksy tale

"*Venue* had been doing a lot of coverage of the graffiti scene and commissioned and helped young talent (including paying 3D to paint the side wall of our office in Jamaica Street, buying paint cans, commissioning Inkie and so forth). We gave Banksy a lot of coverage, and a mutual contact passed on a series of sketches from him for some of his best Bristol pieces, which we put together in a framed collage. That got abandoned in an office move because certain *Venue* staff thought they weren't worth putting in the van!"

Context is important for Banksy. This one is on the side of the Nelson Street police station in Broadmead.

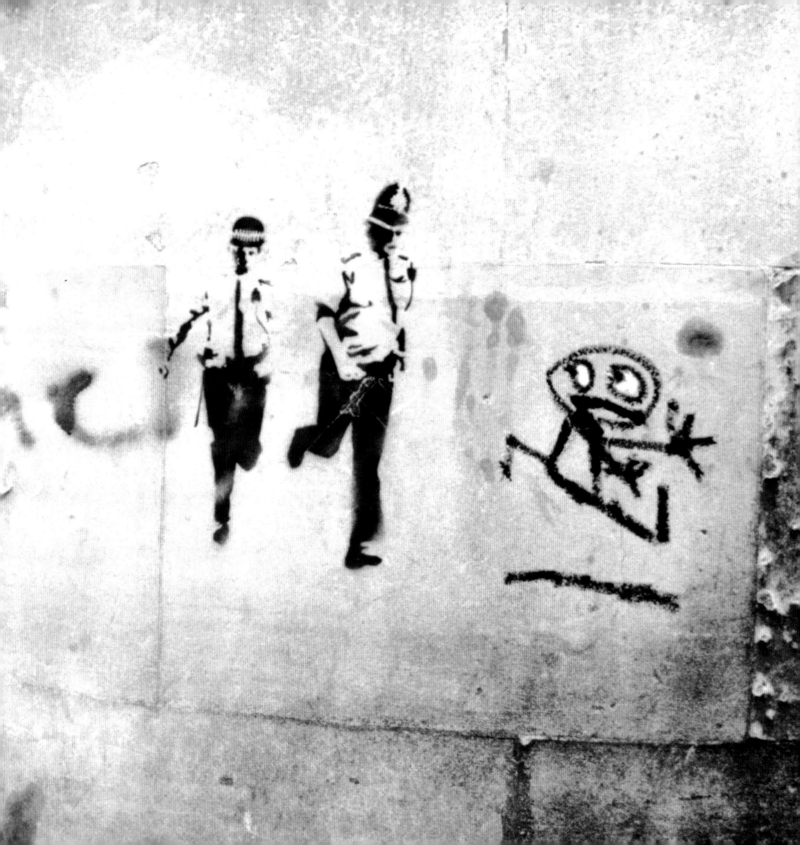

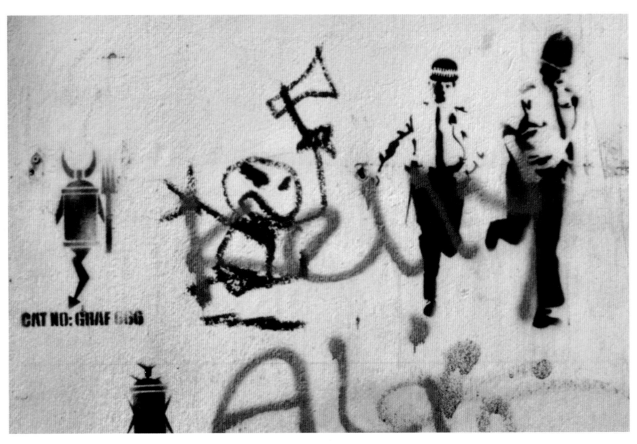

CAT NO: GRAF 666

Banksy backlash

Colin Saysell, British Transport Police and Bristol anti-graffiti officer, who has spent years trying to track down Banksy

"What is one man's art is another man's unmade bed. The debate over whether what Banksy does is art is neither here nor there, because if it is done in a place without permission then it's criminal damage. Banksy is a self-confessed vandal, and that's why he goes to such lengths to keep his identity a secret. Those who support him support these criminal activities and that cannot be right. Why should people in Bristol or in London, or anywhere else, have to pay more council tax to clean it up?"

Veteran art critic Brian Sewell, by voicemail

"A long-delayed response to your letter. I don't know anything about Banksy, and I don't care tuppence about graffiti or street art. Sorry abut that. Talk to me about Michelangelo and I will willingly respond, but Banksy? No."

Jonathan Jones, *The Guardian*, on web blog

"I think there's some wit in Banksy's work, some cleverness – and a massive bucket of hot steaming hype."

Banksy, Bristol and the Lifestyle Effect

Eugene Byrne is a Bristol author and journalist

"I think Banksy's obviously a Jolly Good Thing as far as Bristol is concerned. He's given us a few iconic images (especially the Mild Mild West) and, when you add him into that MassiveHeadTrickySize Bristol sound, it adds to the city's cachet as somewhere cool and edgy. Obviously that whole thing is grossly exaggerated, but it doesn't do any harm.

"But I wonder about the economic benefits of the city's 'cool' image. When you talk about that, people tend to think of it in terms of tourism, but I think of it more in terms of demographics. One of the great mantras of economic development these days is so-called 'graduate retention', the idea that clever people with in-demand skills will move to a place, or stay in a place when they finish university.

"Bristol has very high concentrations of these, and those directing what passes for economic policy in the area know that this 'cool' image is useful (and is of course actually un-threatening – what a lot of graduates want, especially as they get older, is the appearance of rebellion with none of the inconvenient or expensive actuality).

"Now obviously it's more useful if the jobs are there, but for most people, particularly graduates, it's all about lifestyle as well. So one of the amusing ironies is that this street artist with the most impeccable anti-capitalist credentials, is actually adding economic value to Bristol. One of the sharpest examples of this irony is that Banksy's popular Mild Mild West mural is going to be preserved behind glass and shoved in the atrium of some upmarket flats for yuppies being developed on Stokes Croft."

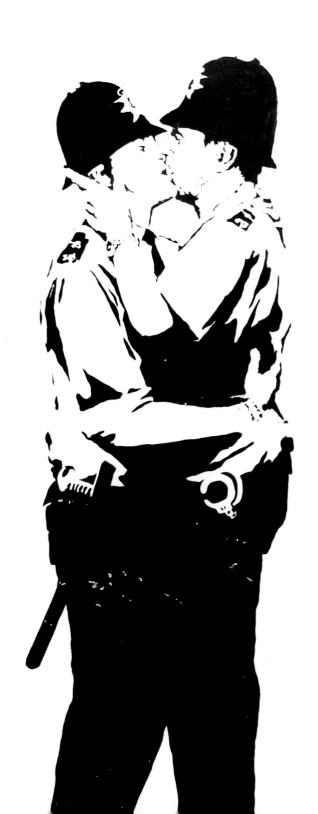

Little black books

A crucial part of the Banksy strategy has been the release of his three 'little black books', *Banging Your Head Against a Brick Wall* (2001), *Existencilism* (2002) and *Cut It Out* (2004). Mixing musings with photos of his work to date, these little paperbacks were later collated into his mega-selling coffee-table book *Wall and Piece* (Century); but, before he was a household name, the books, which originally cost less than a fiver and are now selling at around £40 a piece on Amazon, pushed his name out there with some classic stealth marketing.

"The books were a piece of genius, because they were so accessible," says Banksy collector Martin Roberts. "The best way for him to influence people was to get them reading those books, understanding for themselves what he's about, making them feel they have a stake in the whole Banksy phenomenon. Just the same as with celebrity chefs, the books are a hugely important part of who they are and how they are known – suddenly they're in your homes, you can spend time thinking about them, feel you've got to know them better. "

John Mitchell, former editor of *Venue*, agrees. "Until I'd read his books, I'd never realised how prolific, funny and creative his art was. I'd thought the whole Banksy phenomenon a bit overblown. Seeing how much he'd done – and how good it was – completely changed my opinion of him."

"I admire his business sense, he's been very shrewd," adds Ghostboy. "I remember seeing his little books in the bookshops, and I thought they were a masterstroke. They were £2 or £3 each, by the counter while you were waiting in the queue. You speak to people and they say, 'yeah, I've seen Banksy's work, and you say 'where?', and it turns out that they've seen the books. A lot of people got to know his work that way. People who, previously, had shown no interest in art had those books around their house."

For a guy who once admitted in an interview in *Venue* in March 2000 that his ideal night out in Bristol was: "Off your head on cider and ketamine spitting at things off the edge of the Suspension Bridge", Banksy clearly has an acute business sense.

The three books sold for under a fiver. They go for £40 or more on eBay.

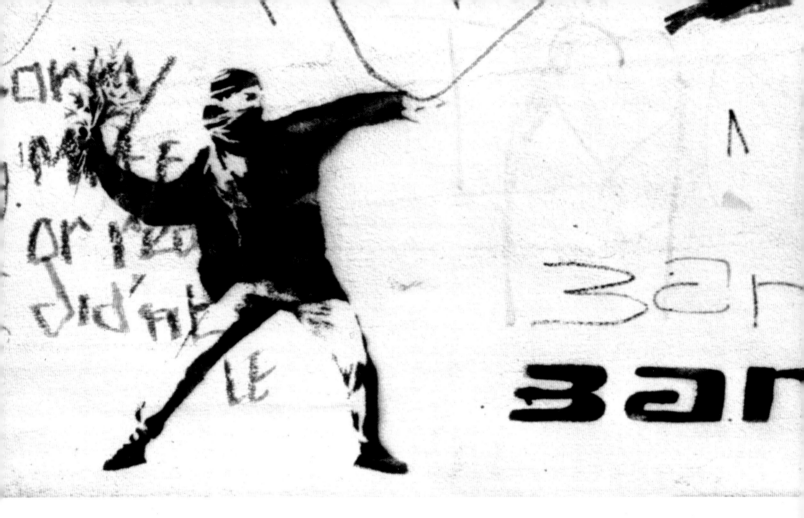

Cut it out

It's not always been possible to say for certain if a 'Banksy' is a Banksy, if you know what we mean. In April 2007, Bristol City Council announced that it planned to remove a mystery 'cut out coupon' (a familiar Banksy design) sprayed on a wall and pavement in Queens Road, Clifton after deciding it was not, in fact, from the hand of our elusive hero. The stencilled dotted black line with a pair of scissors was even accompanied by Banksy's trademark tag, but the council weren't convinced.

"He said it's not him, but he always says that," said Banksy's spokeswoman Jo Brooks mysteriously. The piece was duly removed. One reader promptly wrote in to the *Evening Post*: "Could someone explain to me why the 'cut out coupon' was 'art' when thought to be by Banksy – and, because it is by someone else, it is now graffiti?" Indeed.

A similar debate was triggered by the appearance of a 'Banksy' opposite the Children's Hospital in October 2007. The sniper with a child behind him about to burst a paper bag has all the hallmarks of Banksy's humour and the inclusion of a child (or animal) is a Banksy trademark. But it's not 'signed' which reopened the 'Is it only art if it says it's a Banksy?' issue. Councillor Gary Hopkins said that counterfeit 'Pranksys' should be allowed to remain depending on how 'funny' they are. This elicited an immediate and withering response from the Bristol Blogger: "Sorry there Leonardo, Turner, Cezanne and especially you Goya, I'm afraid you lot don't make the grade any more using Gary's new humour test for real art."

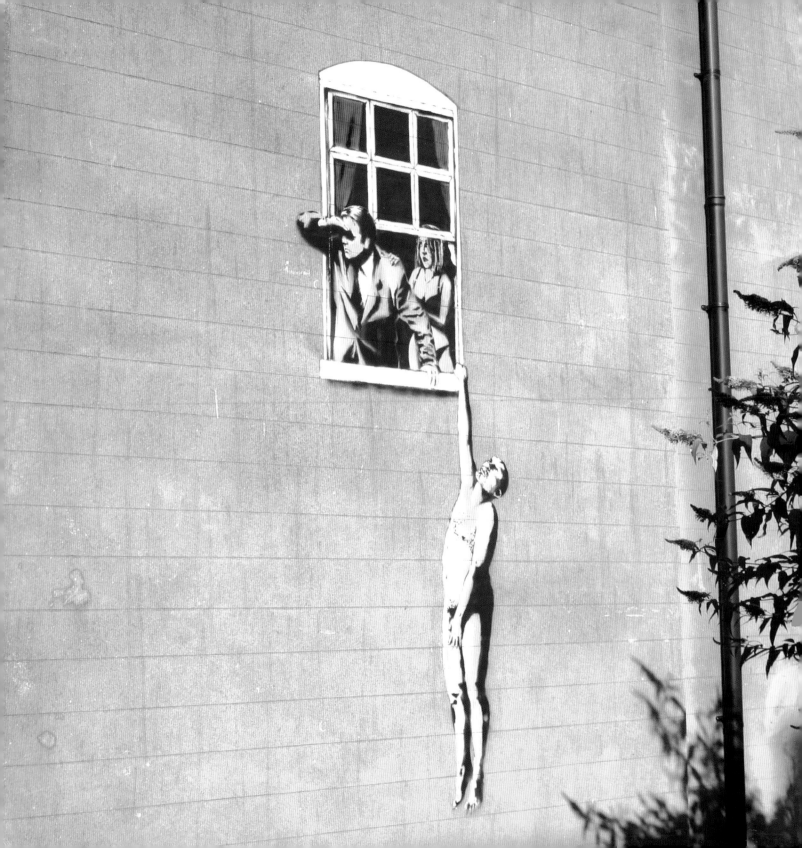

Keep the piece

The debate over the Frogmore Street Banksy

Banksy famously returned to Bristol in June 2006 to paint a mural of a naked man hanging from a window on the side of a sexual health clinic in Frogmore Street, facing Park Street and the Council House. The piece, on the wall of the Brook Young People's Clinic, sparked a heated debate about whether it should be allowed to stay. Lib Dem Councillor Mark Wright said that the image had artistic qualities and launched a petition to save it, to which the local MP Stephen Williams signed up.

"The vast majority of people can see the difference between street art and vandalism," said Wright. "For as long as residents continue to support the Banksy artwork, it should stay. Why should the Council remove something, at significant expense, that most people enjoy and want to stay? What a waste of money that would be."

A Council spokesperson confirmed that "Bristol City Council has not received any complaints from the public about the 'Banksy' on Park Street."

The Council decided to put the question to the public via an online poll. Nearly 500 Bristolians voted, 97 per cent of them in favour of keeping the piece. Not everyone was happy, though – in particular Conservative Councillor Spud Murphy, who commented "It's ludicrous. The Council have gone mad", and warned that the move would encourage more acts of paint-based vandalism across Bristol. "It's absolutely stupid. They will have them all over the city now. They have given a licence for everybody in Bristol to do it. These graffiti artists all think they are better than each other and try to out-do each other."

"The council went through all manner of contortions over the fate of the bloke hanging-out-of-the-window picture," comments journalist Eugene Byrne. "I think it's a mark of his talent that he can spark off this huge storm-in-a-teacup debate about whether or not it should have been painted over."

One of those keenest to preserve the piece was Annie Evans, medical director of the Brook Young People's Clinic on which the image was painted. "We emailed Banksy to explain how wildly appropriate the subject matter was,

That page: Banksy hired scaffolding with sheets around it and painted the Frogmore Street piece. When the scaffolding came down, his latest work was revealed.

bearing in mind we are a sexual health clinic. He replied saying he hadn't realised that and thought it was really funny. He said he hoped it wouldn't be removed straight away. I replied saying they would bulldoze it over my dead body!"

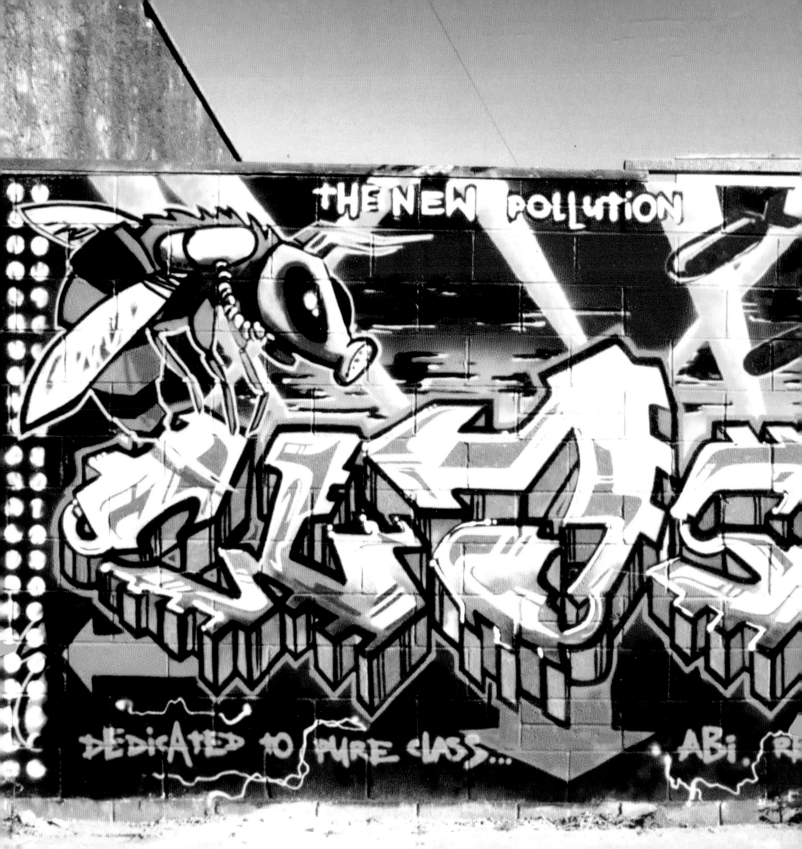

The New Pollution

At the end of 2006, there was much sadness in St Werburgh's, Bristol, over the demolition of a wall named 'Abi's Wall' which featured a Banksy piece titled The New Pollution. It was dedicated to Abi Clay, a young resident of Ashley Hill who died, aged 21, after suffering an asthma attack at the Thekla nightclub. Banksy, one of Abi's friends, designed the mural in early 1998, and other friends painted it.

The piece featured an image of an insect wearing a gas mask, a reference to Abi's asthma: it's thought that Banksy's common image of an angel wearing a gas mask is also a tribute to Abi. It was one of the relatively rare, early freehand (non-stencil) Banksys, and also one of Bristol's earliest pieces of spontaneously-produced community art. Many St Werburghians regard its removal – knocked down to make way for flats – as an act of vandalism.

When the piece was demolished, *The Times* contacted some auctioneers for a valuation of the lost piece. Answer? Difficult to quantify, apparently, but "without a doubt into six figures". David Friedman, managing director of developers Springdale, said: "I was talking to local agents about the value for the future flats, but no-one ever mentioned the sentimental value of the graffiti. If I'd known about it earlier I'd have done all I could to save it."

It seems a shame – when all sorts of public art is being expensively commissioned and the soon-to-open Museum of Bristol is looking for ideas of exhibits that best encapsulate the city – that free, spontaneous public art like this is lost.

Photographer Mark Simmons on The New Pollution

"I photographed this piece in May 1998 before I knew him. I love his pieces that get you thinking and make powerful social/political statements. This was dedicated to a special friend of his who died from asthma, making the piece all the more poignant. It was sited on a busy commuter traffic junction in Bristol, just a stone's throw from primary schools and a doctor's surgery. Powerful symbolism – the masked mutant bee, the attacking bombs and, of course, the irony of the location – it all works towards what he's saying."

There was widespread dismay when Abi's Wall was demolished to make way for new flats. But David Friedman, managing director of developers Springdale says the flats will now be called Abi Clay Court as a mark of respect.

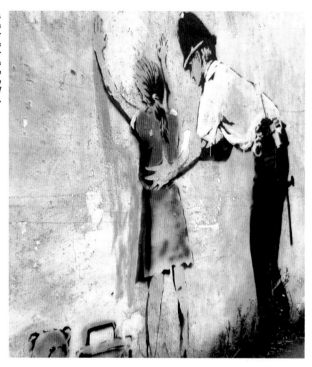

Bristol author Stephen Morris on the Banksy Effect

"Banksy's clever: he delivers great visual one-liners, poking fun at unfaithful wives and cuckolded husbands, grim reapers with smiley faces, buried treasure under Weston-super-Mare beach. No other graffiti artists do this in quite the same way. Some graffiti is very good, but none surprises you or makes you think or laugh like Banksy's.

"Is he a force for good? Bristol City Council mentions him on their Destination Bristol website. He is a tourist attraction, but exposure devalues his place in the counter-culture. He's one of several accomplished graffiti artists associated with Bristol, but perhaps the only one whose name and reputation is known outside of the city. His work doesn't just fill a gap and explore colour and form, it cuts to a message – political, punning, funny, satirical. In this way he's different. He doesn't make big claims for his work, but I think this is a bit disingenuous – nobody goes to Palestine and paints on the peace wall without a degree of political awareness and motivation.

"I don't think his work has great artistic merit, but (like Warhol's cans of soup), it has iconic status. Parody is the key to his work. He's not angry, he won't riot, but he does have a sideways look at hypocrisy and makes us laugh at ourselves and our circumstances."

Bone on Banksy

Ian Bone, founder of Anarchist group Class War, author of *Bash The Rich* and former editor of *The Bristolian* scandal sheet on Banksy
"The creative personality does not seek to shock or entertain the bourgoisie but seeks to destroy them... Banksy is Captain Swing and General Ludd, Spartacus and the Scarlet Pimpernel, Spring Heeled Jack and the Angel of Mons. The Witchfinder Generals will open a thousand coffins, unbrick a thousand priest holes, disinter a princess, but Magwitch will be loping through the long grass of the salt marshes."

Wall-to-wall coverage

A prominent, anonymous Bristol graffer on the Banksy effect
"I respect the guy's work, but I think he is casting a giant shadow over the scene and has created [albeit unwittingly] a horrible state of affairs, where every art agent and dealer is looking out for the 'next Banksy' and the media are unable to focus on any other street artist. I've no interest in being labelled 'the next Banksy'.

"D*Face [another British street artist] is a case in point, an artist whose work panders unashamedly to media hype, often appropriating the same iconic images that Banksy has used – Warhol, £10 notes, and so on – and bringing nothing new to the scene.

"On the plus side, the huge profile and exposure given to Banksy's work has re-opened the debate on vandalism vs. graffiti and has seen Bristol City Council slowly starting to take its street artists more seriously."

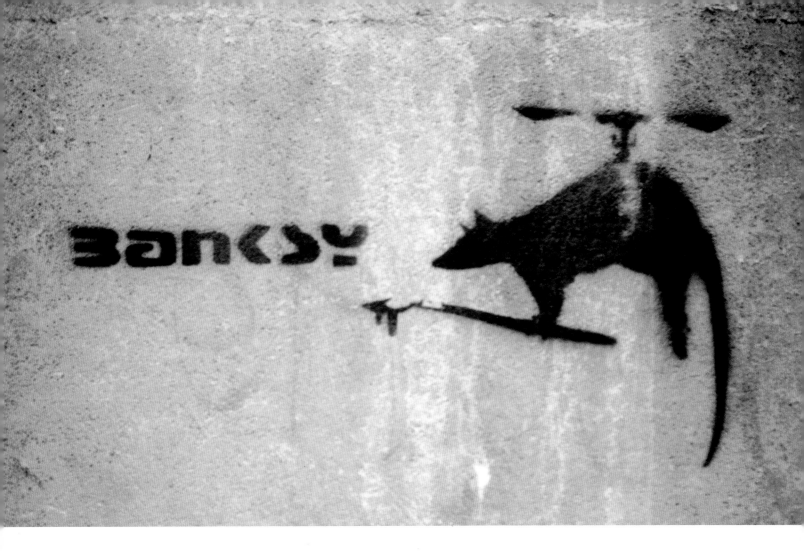

Banksy, by the Bristol Blogger

The Bristol Blogger is an anonymous satirical observer of Bristol's social and political scene who can be found at thebristolblogger.wordpress.com.

Does Banksy belong to a subversive Bristol tradition that runs from riots in Queen Square in 1831 to subvertising more recently?

"I find this whole idea of Bristol as a subversive place a bit of a joke, to be honest. It's a very, very conservative city, still run and dominated by a very, very conservative toff/mercantile alliance (The Merchant Venturers and their circle) who still set the social, political and cultural agenda in the city to a remarkable extent. These tossers crop up everywhere with their culturally conservative agenda eg. Watershed, Arnolfini, Old Vic, Bristol United Press, City Council, voluntary sector etc.

"The reality is that Banksy had to go to London to make a name for himself as he was ignored in Bristol. He follows in a long line of talent such as [progressive nineteenth-century architect] Edward William Godwin and [playwright] Tom Stoppard, who have had to head for London to get noticed.

"Where's the evidence of this subversive culture the city's fostered? It's certainly not capable of supporting or promoting itself within the city, let alone nationally or

The creative personality does not seek to shock or to entertain the bourgoisie but seeks to destroy them.

internationally. And the kind of institutions that might support such a culture (see above) do sod all. Arnolfini and Watershed particularly consistently spend their large budgets on out-of-towners and their ideas.

"And, by the way, I think Massive Attack are the exception rather than the rule in Bristol by the way. It's also worth remembering that we're talking about a band who had their heyday 10 years ago – although they do have a tangential relationship to Banksy through the hip hop/graf thing.

What do you make of Banksy's work?

Extremely well executed. He has that impressive ability to make what has clearly been well thought out and worked through extensively look like it's been thrown together. This gives it its 'street' feel. I'd put him up there with Peter Saville [graphic designer who produced, among others, record sleeves for Joy Division and New Order] and Neville Brody [former graphic designer for *The Face* and *Arena* magazines] in terms of graphic art. I do think if you have to ask the question: "But is it art?" The answer is invariably "no".

You've said on your blog (in connection with Chris Morris) that Banksy's work has only recently been recognised in Bristol. Can you explain a little more? Do you mean that his works used to be summarily power-sprayed out of sight, whereas now the Park Street mural is looked on as a bit of a treasure?

Pretty much. Most of my comments are aimed at Bristol's establishment who couldn't give a toss about Banksy. They just see a new marketing opportunity for the city (and by extension their businesses). Plus they're so tasteless and moronic that if London says something's good, they'll believe it regardless. Whereas if something under their noses is good, they'll ignore it unless they're told it's good by someone from *The Guardian*!

Boghenge at
Glastonbury
Festival 2007.

Is there some irony that Banksy, with his impeccable anti-capitalist credentials, is adding to Bristol's economic, tourist and property values?

It's not ironic. And his credentials aren't impeccable! You can't bring down capitalism through the art market – a pillar of capitalist accumulation. It was true then and it's true now. The purpose of entering the art market is to make money. What else is it for? Anybody who thinks they can spark a revolution, create the new Jerusalem, redistribute wealth or feed the starving via the art market is a twat.

Is the media too slavish in its admiration of Banksy?

Yes. It's well-crafted anti-capitalist agit prop FFS. It's interesting to note that most of the journalists writing about Banksy tend to be establishment news reporters, rock critics, Sunday supplement interviewers etc. who seem to have a romantic and uncritical approach to the whole 'street' thing. I think he's hooked into that big audience of male, white, middle-class, graduate Nathan Barleys who are on a black/working class/street/authenticity trip.

Has he been a force for good in Bristol?

Yes. He makes us look smart and streetwise.

The lack of
a tag on the
October 2007
Banksy
re-ignited
the whole 'But
is it art?'
debate.

further reading

Books
Banksy, *Wall and Piece,* Century, 2005 (reprinted 2006)
Beezer, *Wild Dayz*, Petit Grand Publishing, 2003
Cooper, Martha/Chalfant, Henry, *Subway Art*, Thames & Hudson, 1984
Ganz, Nicholas/Manco, Tristan, *Graffiti World: Street Art from Five Continents*, Thames and Hudson, 2004
Gillespie, *The Naked Guide to Bristol*, Tangent Books, 2006
Manco, Tristan, *Stencil Graffiti*, Thames & Hudson, 2002 (reprinted 2006)
Manco, Tristan, *Street Logos*, Thames and Hudson, 2004
Morris, Stephen, *Off The Wall: A Book of Bristol Graffiti* Redcliffe Press, 2007
Various, *Political Street Expressions in Bristol and the South West*, Bristle Magazine, 2005

Magazines
www.adbusters.org *Adbusters* – Vancouver based anti-consumerist magazine
www.bristle.org.uk *Bristle* – Alternative publication for Bristol and the south-west, providing news and action for the local radical community
www.venue.co.uk *Venue* – Bristol and Bath's weekly listings and features magazine

Websites – general
www.artofthestate.co.uk Graffiti news and images
www.bristolgraffiti.com
www.graffiti.org Worldwide graffiti scene
www.stencilrevolution.com Comprehensive stencil art website. Galleries, tutorials, forums, artist profiles and more
www.bristolbeat.co.uk Now-defunct online Bristol magazine, but features a tour of Banksys still in existence at the time
www.picturesonwalls.com Site selling original prints by Banksy and others
www.letthemhang.co.uk Limited edition, hand screened prints by Eco, Dicy, Xenz, Paris, Sickboy and others.
www.kuildoosh.com Design collective for Bristol artists

Eko, Mudwig and Paris
www.wonderfulworkshop.com Bristol store with regular street art exhibitions and sales
www.graphicattack.org.uk Subvertising in Bristol
www.woostercollective.com "A celebration of street art". Regularly updated galleries and features
www.beezerphotos.com Seminal photos of 80s Bristol hip hop and graffiti culture by photographer Beezer
www.lazinc.com Website for the Soho gallery run by Banksy's agent Steve Lazarides

Websites - artists
www.banksy.co.uk
web.mac.com/nickwalkerz
www.myspace.com/inkie70
www.myspace.com/cheba_bristol
www.ghostboy.co.uk
www.xenz.org
www.grahamdews.com (Paris)
www.flickr.com/photos/feekertron/ (Feek)
www.mrjago.com
www.willbarras.com
www.thesickboy.com

If you like Banksy try...

Ghostboy Bristol stenciller with a similarly sharp, wry, and often political style.

Paul Insect Artist and designer applying a mix of 'gothic Victoriana and futuristic themes'.

Stanley Donwood Reclusive author and illustrator best known for Radiohead album artwork.

Adam Neate London artist who leaves his paintings on the streets for passers-by to claim.

Antony Micallef Figurative painter with a dark, troubling palette. Has been described as 'Caravaggio meets Manga'.

Jamie Hewlett 'Tank Girl' creator and provider of Gorillaz album artwork.

Blek le Rat Pioneering French stenciller with a style similar to Banksy's, who's been decorating the streets of Paris since 1981. Banksy once observed, "Every time I think I've painted something original, I find out that Blek le Rat has done it as well, only 20 years earlier."

Faile New York poster and stencil graffiti collective.

Nick Walker The original Bristol stencil artist, with brilliantly humorous, provocative and often sexual themes.

Swoon Female NY street artist specialising in lifesize cut-out 'street people'.

Zero Lubin Emerging Bristol situationalist and founder of the New Nostalgia movement. Also produces a range of 'esoteric' Banksy greetings cards.

777 Florida Street
San Francisco, CA 94110
www.lastgasp.com